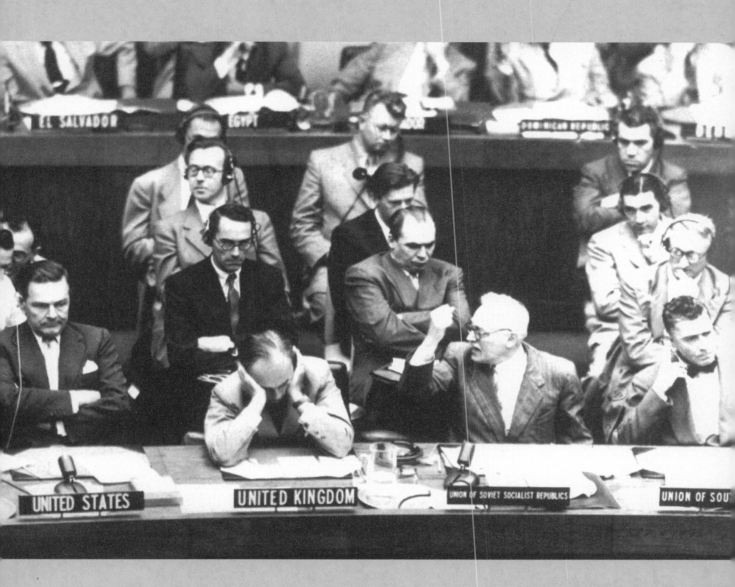

MUNTADAS

ON TRANSLATION: THE GAMES

CHRISTOPHER SCOATES, RONALD CHRIST, MARGARET MORSE AND CHRISTOPHER PHILLIPS

THE ATLANTA COLLEGE OF ART GALLERY

Published by the Atlanta College of Art Gallery in conjunction with **On Translation: The Games**, an exhibition at the Atlanta College of Art Gallery, Atlanta, Georgia.

June 7–August 4, 1996

The exhibition **On Translation: The Games** is a collaboration between the Atlanta College of Art Gallery and the 1996 Olympic Arts Festival.

Catalog design: Andrew Blauvelt, Raleigh, NC
Editor: Jane E. Neidhardt, St. Louis, MO
Printing by: Phoenix Communications, Inc., Atlanta, GA
Paper: Strathmore Elements Bright White Solid 80 lb. Text & 110 lb. Cover

ISBN 1-881616-74-6
Printed and Bound in the U.S.A.

Atlanta College of Art Gallery
The Woodruff Arts Center
1280 Peachtree St., N.E.
Atlanta, Georgia 30309

Continuing support for the Atlanta College of Art Gallery is provided by the National Endowment for the Arts, the Georgia Council for the Arts, the Fulton County Arts Council and the City of Atlanta Bureau of Cultural Affairs, as well as by generous contributions to the college by individuals, foundations and corporations.

Available through Distributed Art Publishers
636 Broadway, 12th Floor, New York, NY 10012
212-473-5119 (T) / 212-673-2887 (F)

TABLE OF CONTENTS

The Atlanta College of Art is especially pleased to exhibit *On Translation: The Games* in association with the Olympic Arts Festival of the 1996 Centennial Olympic Games in Atlanta. With this installation, Muntadas has transformed the Atlanta College of Art Gallery into a multimedia environment of thought, dialog, interaction, education and art. We are proud to have this internationally recognized artist create a new work as our linkage to the world during the 1996 Olympic Games.

The Atlanta College of Art Gallery is a particularly appropriate site for *On Translation*. For almost seventy years, the College has educated artists and designers whose mission is to translate ideas, experiences and passions into art. Exhibitions like *On Translation* and continuing programs such as our International Artist and Designer Residencies and World Cultures Core Curriculum strengthen the College's engagement in the international community of artists. We believe that this involvement is essential for the relevant education of the next century's artists, designers and citizens. In its role as a founding member of the notable cultural partnership of Atlanta—the Woodruff Arts Center—the College, through its programs, also serves as a conduit between art and design and this city.

For the past twenty years, Muntadas has raised questions about the use and abuse of text and artifacts, the denaturing of the spoken word, image and space. He has revealed the complicity of architecture in coercion, exposing spaces designed for both public and more privileged rituals as stages for affirming an anonymous, but all pervasive, power. With staccato elegance and clarity, the installations of Muntadas have also inquired into the exhaustion incumbent upon living amidst the proliferation of information that does not inform, the atomization of communal experience—despite the saturation of daily life with communications technology and the unbreachable current of commerce that has become both the medium and the message.

Muntadas' work has captured the tension between glossolalia and Esperanto, the ambiguities, paradoxes and complexities inherent in the modernist dream and nightmare of a global culture perfected by technology. On a day-to-day basis, we have the sense that we inhabit a science fiction novel half-remembered from childhood—from Zapatistas reporting on atrocities via e-mail at locations inaccessible to journalists, to a recent satellite discussion between exiled author Salmon Rushdie from an undisclosed location in London and Mexican novelist Carlos Fuentes and several hundred Brown University students in Rhode Island, to isolated individuals sharing the virtual architecture of America Online. *On Translation* provides incisive observation and commentary on symptoms of the curious condition of global culture and the meaning of language at the end of the twentieth century.

On Translation: The Games, is a collaboration between the Atlanta Committee for the Olympic Games Cultural Olympiad and the Atlanta College of Art Gallery. The College would like to express great appreciation to the Cultural Olympiad, as well as to the National Endowment for the Arts, the Georgia Council for the Arts, the Fulton County Arts Council, the City of Atlanta Bureau of Cultural Affairs, individual and corporate contributors to the exhibition and the Board of Directors of the Atlanta College of Art for making this exhibition possible. In addition, I would like to congratulate Gallery Director Chris Scoates for the vision to pursue the development of this installation. We are most grateful to Muntadas for his generosity and for bringing his thought-provoking installation to the site of the latest edition of one of the great modern symbolic experiences—the Olympic Games.

Ellen L. Meyer
President
Atlanta College of Art

ACKNOWLEDGMENTS

We at the Atlanta College of Art Gallery take great pleasure in being able to host this exciting new installation, *On Translation: The Games*, by Muntadas. Muntadas spent several weeks at the Atlanta College of Art completing the final plans for the realization of this installation. We are especially proud to be part of *On Translation: The Games*. Its presentation here is a part of the 1996 Olympic Arts Festival in Atlanta. *On Translation* is a provocative media-architectural installation that casts light on the practices and values embedded in the act of interpretation and translation between languages, cultures and societies.

The realization of this project would not have been possible without the help and dedication of many people. Chief among them is Atlanta College of Art President Ellen Meyer, whose enthusiasm and dedication to the project is especially appreciated. I would also like to thank Annette Carlozzi, Producer of the Visual Arts Programs at the Cultural Olympiad, for her endless support, good grace and supreme professionalism; Ruth Resnicow, Visual Arts Coordinator at the Cultural Olympiad, who assisted in many ways and handled a myriad of details; Stephan Hillerbrand, who assumed responsibility for many of the project's challenges; Cedric De Souza, for his in-depth and persistent picture research; Sara Hornbacher, for her patience, hard work and assistance with the exhibition's video component; Crawford Communications Inc., who assisted in the post-production of the video; and all the students who deserve praise for their hard work and enthusiasm, including Carolyn Mendoza, Kemba Sewer, Amy Armour, Kim Rhodes, Jennifer Lowery, Heather Parrish and Gregory Wilson.

My utmost thanks to catalog essayists Ronald Christ, Margaret Morse and Christopher Phillips, whose contributions here enliven the practice, discussion and understanding of Muntadas' work. A special thanks, as always, to Jane Neidhardt for her editorial expertise and meticulous attention to detail, and to Andrew Blauvelt for his beautiful design of the exhibition poster and catalog.

I continue to be grateful for the special assistance provided by the National Endowment for the Arts, The Atlanta Committee for the Olympic Games, and the continuing support for the Atlanta College of Art Gallery by the Georgia Council for the Arts, the Fulton County Arts Council and the City of Atlanta Bureau of Cultural Affairs, as well as for the generous contributions to the college by individuals, foundations and corporations, without whose support this project would not have made it past the conceptual state.

Finally, I wish to thank Muntadas for giving us the opportunity to present *On Translation: The Games* at the Atlanta College of Art Gallery. The same intelligence, attention to detail, sense of humor and prescient political observations which inform his work have made working with him a truly pleasurable and rewarding experience.

Christopher Scoates
Director
Atlanta College of Art Gallery

9

PROJECT NOTES

I began thinking about translation while still working on two previous projects: finishing *Between the Frames: The Forum* and starting *The File Room*. Both of these projects brought to the foreground of my attention the power, implications and responsibilities of translation relative to subjective decisions and objective results.

Basically, the translation project emphasizes the *between*—that act or individual in the middle of the communication process, the process of emitting/receiving a message. The intention is to focus in each of the project's venues on a specific local or international fact or event that involves issues of translation in a precise situation, which also serves as a background for the presentation.

The first in the series of presentations related to the translation project was *On Translation: The Pavilion* in Helsinki, Finland. As part of ARS 95, I took the main event of the 1975 C.S.C.E. (European Conference on Security and Cooperation), which was held in that city, as a background and point of departure because translation was very important in the conference's cultural and political context—local as well as world-wide—since Finland at that time was isolated and removed. I focused on the specifics of the conference in order to counterbalance abstraction—in order to make the project something more than or different from a philosophical discourse about translation.

Then, in 1994, I started working with Christopher Scoates on a second presentation in Atlanta, scheduled for later that year, and I initiated a process of research and development. As in Helsinki, I began working in Atlanta by exploring the city—its context and its history—in order to discover and define an important cultural event on which to base the next phase of *On Translation*. But when Christopher Scoates mentioned that Annette Carlozzi, Producer of the Visual Arts Program of the Cultural Olympiad and presenter of my earlier *Stadium VI* in New Orleans (1991), was interested in presenting the translation project in conjunction with the 1996 Olympic Games and was able to provide better conditions to work in, I agreed to accept the offer as an exhibition co-produced by the Atlanta College of Art and ACOG (Atlanta Committee for the Olympic Games). However, I stipulated that the agreement be unconditional; there would be no limitations, restrictions, impositions, interferences or concessions, requested or required, of any kind by the organizers of the Games, and furthermore, there would be *total freedom* for the development of what was already an on-going project.

Early on I realized it was naive to believe that any work presented in Atlanta simultaneous with the Games would be viewed as disconnected with and unrelated to the Games. Furthermore, the connection between the subject of translation and the Olympic Games as a worldwide event became clear. Flags and national anthems, the symbols and logos of the Games and their spirit, all relate to issues of translation and raise the question of how people translate the *values* of their nations. This consideration raises the question of how nations are represented officially in cultural, political and diplomatic arenas—in short, how the Olympics are a *translated* event. *On Translation: The Games* thus came to deal with the games of translation and the Games of the Olympics.

The project as a whole in each presentation looks at translation from a different angle and considers different aspects. The series must be thought of as installations intended to confront translation from a broad perspective, considering translation, interpretation and transcription as interrelated activities moving from

<div align="center">

language to codes
silence to technology
subjectivity to objectivity
agreement to wars
private to public
semiology to cryptography

</div>

For the Atlanta presentation, I especially wanted to consider the role of translation and translators as a visible/invisible fact, making use of metaphor but also incorporating this fact in the actual physical construction of the installation. Since translators are always hidden, why not bring them forward and make them not only present in but central to the work?

Then, too, I wanted to consider the idea of the *official* translator, whether in written word or in oral, simultaneous translation. In sum, I wanted to make the act of translation recognized, authorized, credited—acknowledged, even—as the only way to "understand a message," and therefore as an important part of both sets of Games.

Muntadas
Atlanta 1996

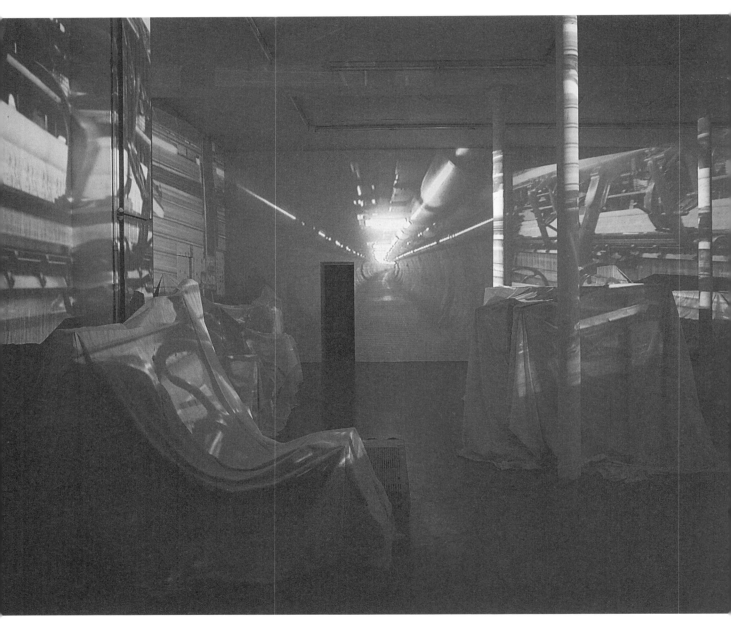

Muntadas. **Ici/Maintenant**. Galerie de l'Ancienne Poste, Calais, France, 1994.

On Translation: The Games
A Curatorial Perspective

CHRISTOPHER SCOATES

Not every word in one language has an exact equivalent in another.
Thus, not all concepts that are expressed through the words of one language are exactly the same as
the ones that are expressed through the words of another.[1]

In this most recent installation, *On Translation: The Games*, Muntadas continues his critical analysis of the media and its effect on the relationship between private and public spaces in contemporary society. For the past fifteen years Muntadas has developed multimedia installations that employ deconstructive strategies to reveal the symbolic and political meaning encoded in media archetypes, constructions or architectural representations such as the art gallery, the board room, the stadium, the automobile and the home. In these works Muntadas analyzes power relationships, revealing and exposing the value systems that lie beneath them—developing an artistic practice as part of a much larger ongoing struggle against the forces of social apathy. He says that he is interested in "dichotomies of relationships, for example objective/subjective, public/private, indoor/outdoor. These extremes provide me with a structure. They are like sets of stereotypes, but I am interested in what lies between the two extremes."[2]

The exhibition *On Translation: The Games* builds on themes and ideas of Muntadas' earlier projects, such as *Between the Frames: The Forum, Exposicion, Quarto do Fundo (The Backroom)* and the *City Museum*, which focused on the relationship of the city to cultural industry, tourism and spectacle. Muntadas uses the 1996 Olympic Games in Atlanta as the conceptual, political, cultural and social backdrop for the installation. As with these previous installations, Muntadas draws upon architecture to convey something of the physical setting or site of the spectacle of culture. The design of *On Translation: The Games* is based on a topological analysis of translators' soundproof booths. Translators or interpreters are commonly set off to the side and are made invisible from the main meeting or conference—traditionally enclosed in small, non-obtrusive soundproof booths to the periphery of the central event. Muntadas, however, reverses this dynamic by focusing not on the "meeting" but on the role of the translator or interpreter, investigating how the translation of information is a mixture of subjective and objective decisions with profound effects on culture, politics, economics and personal relations.

The installation offers an analysis of the power structure that demarcates the spaces and borders between translation, language, culture and audience. The various voices that purvey ideology—media, literature, politics and culture—are foregrounded. Muntadas has always been interested in the way information gets manipulated through a variety of filters. Clearly, this new work is an attempt to explore the ways in which translation as a central mode of political discourse transforms our sense of reality. Rather than conveying a personalized statement about the act of interpretation, he encourages a critical sensibility about it. With this work he wishes to bring together various ideas drawn from or brought to the concept of translation as a way of entering into the mechanisms that make cross-cultural communication and understanding possible.

The essays for this book were written so that a more complex analysis of Muntadas' work could be outlined. Together they provide an important examination of his past works. In her essay "Muntadas' Media-Architectural Installations: On Translation," Margaret Morse surveys Muntadas' work from the past decade and explores his ongoing interest in cultural archetypes as complex hybrids of image and architecture. While featuring works such as *Exposicion*, *Stadium*, *The Board Room*, and *The Press Conference Room*, Morse focuses on Muntadas' built environments and examines how he employs architectural strategies to form a more elaborate discussion about media, spectacle and architecture. Christopher Phillips focuses specifically on Muntadas' video projects in his essay "Architectures of Information: The Video Work of Muntadas." Beginning with *Collective Experience No. 3: Smell, Touch, Taste*, a video from 1971, Phillips traces and outlines the development of Muntadas' ideas, themes and issues through seminal works ranging from *Slogans* of 1986 to *Political Advertisements* of 1992. In his essay "Found in Translation," translator Ronald Christ looks at the fundamental nature of translation in a cultural context by considering it far more broadly than a treatment of literary translation would do. His essay provides a more personal perspective and focuses on lesser-known voices and lesser-known aspects of translation, such as subtitling and interpreting, and avoids a review of theory or scholarship.

The act of translation and the reflection upon its function and usefulness for all kinds of political, economic, and literary studies are in general an important, and often controversial, aspect of the tradition of western culture. Many writers and scholars of the past and present have practiced the art of translation, and their practice prompted them to give expression to their insights into the translation process.[3]

On Translation: The Games again documents Muntadas' desire to create works that outline the need to reframe the notion of art for "public" space and the need to open up new avenues for reflection. Consisting of videotaped interviews, newspaper reports, magazine articles and slide projections, this show is a collection of politically and socially grounded critiques about the 1996 Olympic Games in Atlanta. Understanding that the Olympic Games form a complex set of coded texts which have been carefully scripted against a backdrop of larger cultural forces and political institutions, Muntadas wishes to "translate" and "interpret" the links between public and private interests, consumer goods, public relations, economic and political agendas, the sports events, and languages. Ultimately, he examines how cultural mythologies and power are created and expressed.

As with Muntadas' earlier works, *On Translation* explores how people can reclaim their lives in the face of determining ideologies. Once again, Muntadas' goal is to create an installation that provides the public with an opportunity for an extended discussion of the issues. Unfortunately, few public forums exist where citizens who feel passionately about a particular issue can respond. Too frequently people feel disengaged and alienated from the political system and feel as if their voices and opinions do not count. This installation is designed to counteract that.

Exhibitions that transgress the carefully guarded boundaries between public and private and reclaim definitions and images of power from their overdetermined and problematic public mythologies are rare. Curatorially then, this work is extremely important because it attempts to open up new avenues of public discourse and fashion representations that illustrate social and political conditions in their full contexts (as difficult as that may be). While critical and public definitions of art and art practice have changed dramatically over the past twenty years, many art museums, galleries and art schools continue to support conventional projects that promote the separation between "art" and "life." Instead of embracing new educational approaches to difficult issues, art institutions typically promote, teach and emphasize the importance of the unique individual, abstract notions of freedom and a sense of aesthetics divorced from politics. Not wanting to upset board members, trustees and potential donors and more concerned with economic motivations, fragile financial positions and possible public relations nightmares, art administrators tend to develop programs that avoid challenging our perceptions of art, art institutions and society in general.

If art organizations are to play an important role in their communities, they need to promote programs that address the effective means by which art can reach beyond aesthetics to both the individual and a broader relevant context. The role of the curator, artist or teacher must also change. Cultural workers need to redefine the role of arts in society. How can galleries be turned into a public forum for the exchange of ideas and function as places where citizens who feel passionately can respond? How do we curate exhibitions, and how can artworks become more productive tools for social change?

Many of the answers lie in a more complicated definition of art, education and pedagogy. Clearly, we need a conception of pedagogy that is able to address the larger concerns of education and integrate them with those working, not only in the arts, but in other fields such as social work, law, architecture, religion and medicine as a way of building a broad-based community coalition with the common goal of collective emancipation. Artists need to create works that open up political dialogue and stimulate community participation, audience interaction, analysis, awareness and comprehension. Joining critical education and critical art practices together requires that both art institutions and artists develop different approaches for social change by radically altering their relationship to their audience. This is not to imply that there are not numerous artists and collectives already working towards these means; however, few artistic models constructed around issues of pedagogy, art and public education currently exist in the art world. Artists seem unwilling to see themselves as educators and all too often ignore the way politics and power influence predominant perceptions of the relationship between art and culture.

With neo-conservatives once again gaining control of the cultural realm and attempting to exclude those voices that contest the status quo, it is of primary importance that cultural workers address the gap between civic participation and social apathy. How can we take up pedagogy as a form of cultural politics to address how art gets produced and how it comes to function in the broader arts community? We need to ask difficult questions about the role of the artist and art institutions. How can a work of art develop an understanding of civic consciousness? For what audience is art being made? Can a work of art provide a way for the community to enlarge its own identity? Can the arts address the challenge of multiple audiences?

The answers to some of these questions are not as elusive as we may think. If we look back at the emancipatory struggles of the twentieth century—the women's movement, the gay and lesbian movement, the civil rights movement and the environmental movement—we see groups coming together with a shared common political interest and a realization that change takes place within communities by organizing at the grassroots level. Many of these organizations thrived on activism as their main driving force. Artists, curators and other creative workers can play an important role by providing the cultural glue for these communities. As cultural theorist David Trend points out,

> It is incumbent upon radical educators and artists to assist in reconstituting an arena for civic dialogue by validating the significance of a people's culture and recovering the public function of art. In doing so, cultural workers must recognize their roles in the development of civic consciousness. This means promoting notions of shared responsibility for community life, along with the belief that change is indeed possible. At the core of this issue lies political education. That is what convinces people that individual acts of citizenship (like voting) can make a difference—that they themselves can command the authority to make community decisions. [4]

Organizing exhibitions like *On Translation: The Games* that are eminently political or social in nature is a curatorial attempt to redefine education and artistic practice as part of a much larger ongoing struggle nationwide. However, creating even the smallest glimpse of democratic culture at work requires that people engage and participate in the process. Through exhibitions such as *On Translation: The Games*, Muntadas makes it clear that important issues still need to be addressed by individuals and collectives operating at the interstices of public life, citizenship and community participation. In his essay "What Is To Be Undone: Rethinking Political Art," artist and writer Richard Bolton's comments on community apply well: "communities strengthen identity; struggles by communities, rather than by lone individuals, may be the only effective means of generating significant and lasting change. Shared interests create strong bonds and a base from which to work for change."[5]

It is true that projects like *On Translation: The Games* need to address the concerns of communities regularly deprived of mainstream media coverage. However, if politically engaged artistic production is to function more than as a utopian substitute for proper politics, important changes lie ahead. Achieving the level of community activism required for significant change means encouraging large groups to act politically—encouraging action against local or national governments and corporate bureaucracies. This is a tough pedagogical task. It requires that citizens dispense with old habits and reject past expectations in an effort to focus on the political structures that hold apathy and indifference in place. Therefore, socially driven art projects such as *On Translation: The Games* must subvert conventional artistic forms just as their content must criticize dominant ideology. As artist Karen Fiss states, "The goal of activist art is not to aestheticize politics but to politicize the realm of aesthetics."[6]

Because organizations are less willing to stand behind exhibitions and programs that are politically driven, developing challenging curatorial projects has become increasingly more important. Curating and developing educational programs is one of the few ways left for cultural workers to examine the difficult issues of the time and defend and propose and incite difference.

In addition, it is important that artists, curators and radical educators continue redefining education and artistic practice as part of a much larger, ongoing cultural struggle nationwide. And as we move into a time when cultural spaces become less defined, identities less fixed and community groups less settled, the pedagogy of cultural representation must do more than simply recognize, champion and expose the injustices of others. It must begin to create the conditions of political and social reform at the institutional level by aligning power and privilege to rework the relationship between identity and difference. It must function to erase the ideological gaps that exist between diverse constituencies and build bridges between people by encouraging everyday cultural production as a means of empowerment. And it must offer a vision of collaboration and a belief that change is indeed possible—in part by requiring audiences to engage in an act of political imagination, in part by offering a positive agency that invites an active citizenry.

We are surrounded by a multitude of narratives that have developed out of numerous histories, economic relationships, institutional influences and human desires. One of the many important elements of this particular project is that it calls into question the construction of authority and power and addresses the need to bring attention to those interests that construct our identities—the essence of social critique. By presenting a view of the world that is horizontal rather than vertical, artists, curators and teachers can create an experience for viewers that softens the contours between amateur/professional, mass/elite and high/low, allowing a more critical reading of information. At a time when obstacles in society seem even more intractable and the possibilities of widening the range of political attitudes seems increasingly distant, a pedagogically-oriented approach to art will at least open up a dialogue and raise the volume of discussion about the dynamics of political address and intervention within communities. An emphasis on these tasks will lead to a whole set of new issues: Is there a way we can bring together diverse communities as a way of building a truly populist political art? In what ways can we begin to broaden practice within various sites of cultural production so that contemporary art is not seen as a formalist practice that only specialists understand? Muntadas' artistic and pedagogical practices significantly contribute to a consideration of these very issues and concerns.

NOTES

1. Arthur Schopenhauer, "On Languages and Words," in *Theories of Translation: An Anthology of Essays from Drayden to Derrida,*" ed. Rainer Schulte and John Biguenet (Chicago: The University of Chicago Press, 1992), p. 32.

2. Muntadas, in an interview with Nena Dimitrijevc, "Muntadas' Journey through the Stations of Power," in *Muntadas: Intervençōes: A Propósito do Publico e do Privado*, exh. cat. (Porto, Portugal: Fundãçao de Serralves, 1992), pp. 46-48.

3. Schulte and Biguenet, in their introduction to *Theories of Translation*, p. 1.

4. David Trend, *Cultural Pedagogy: Art, Education and Politics* (New York: Bergin and Garvey, 1992), p. 105.

5. Richard Bolton, "What Is To Be Undone: Rethinking Political Art," *New Art Examiner* (June 1991): 25.

6. Karen Fiss,"When Is Art not Enough?: Art and Community," in *Discourses: Conversations in Postmodern Art and Culture*, ed. Russell Ferguson, et al. (New York and Cambridge: The New Museum of Contemporary Art and MIT Press, 1990), p. 156.

Muntadas' Media-Architectural Installations: On Translation

MARGARET MORSE

"I don't think in one piece, but in the discourse between pieces."—Muntadas[1]

Borrowed Voices: The Translation Booth

Without headphones over one's ears, the murmurings from the back of the room at the symposium in Prague were difficult to tune out. Three translators sat behind slanted panes of glass in open booths and spoke simultaneously into separate microphones. Their voices mixed different tongues into an undertone of cacophony or heteroglossia that accompanied each speaker. To put the headphones on, however, was to instantly purify auditory space into one voice in one language.

At a conference in Montreal, the separation between simultaneously unfolding worlds was more complete. The translators sat in free-standing sound-proof booths like little huts with picture windows. Each translator was connected to the audience only via one-way radio transmission. Taking the headphones off or putting them on transformed the room instantly into French or English linguistic territory. Of course, the ventriloquistic illusion was not complete: there was a temporal lag between the speech on stage and the male or female voice in one's ears that seldom matched the speaking body at the podium. Nonetheless, an erasure of bodies and voices had taken place. Furthermore, the work of transmitting one language in another had also become seemingly transparent, or at least concealed inside the room within the room. As a result, the act of cultural exchange became more impersonal and automatic, like a utility to be turned on or off at will by switching the headphone dial.[2]

Of course, the role of translator has an ambiguity that has been historically regarded with a sense of unease or danger, moving as it does in-between territories and loyalties. Since the act of exchange can involve gift and theft as well, a list of great translators might also include by repute some of history's greatest villains. No wonder the body of the translator and the act of translation are often repressed or subordinated in the attempt to neutralize a function that global interdependence makes all the more essential. The translator's booth is the external sign and archetype for that discourse and that practice. Of course, it is the media, in this case, radio, that allows multiple languages to occupy the same space and time, aided by the voice from the booth, a room within a room, much like the control booth in a television studio.

It is the task of *On Translation* to foreground the work that is hidden in the quest for greater association and communion among peoples, be it cultural, diplomatic, economic and/or Olympic. Muntadas, a Catalan who has lived in New York since 1971, is an incessant global traveler and cultural go-between. Muntadas has characterized himself as "transnational" (not international) and local, meaning, for one thing, that he is not "positioned" by such an identity as "nation." His work is nomadic and often serial, repetition with a difference, like a tent put up in different cities that reflects the special light, sounds and smells of each place. Mikhail Bakhtin characterized the advantages of such "outsidedness" in the ability to uncover semantic rich-

es unanticipated by those who live in a particular time and place. Muntadas' emphasis on archetypes in a time of cultural transition suggests a concern for what Bakhtin calls "long time," or the macro scale in which the possibilities of cultural forms unfold.[3] On the other hand, many Americans in the comfortable position as speakers of an almost obligatory world language may, paradoxically, be less aware of the work and the obstacles involved in really listening to the other, the foreign speaker or alien. Muntadas' installation offers us the opportunity for such nomadic experience as wanderer within a world in which we have no "place."

On Translation: The Games is the second piece in a long term project on the topic of various forms of transcription, codification and transfer, the first being On Translation: The Pavilion (1995), an exhibition that took place in Helsinki, the city of the Conference on Security and Cooperation in Europe in 1975. This present installation is also part of a far longer series that embodies contemporary cultural archetypes as complex hybrids of architecture and image, like our environment itself. From the stadium, the board room, the house/home, to the gallery, the art world and even the city as museum, Muntadas' media-architectural installations take account of the displacement and transformation of archetypal cultural forms by print, radio, television and, most recently, the computer.

Architecture and Archetype

Building types such as house, stadium and forum have become archetypes because they embody cultural practices that have persisted across the centuries, shaping daily life and social roles through the organization of space within them,

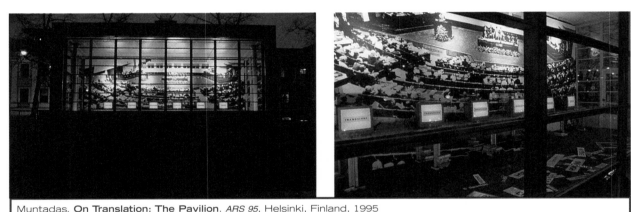

Muntadas. **On Translation: The Pavilion.** ARS 95, Helsinki, Finland, 1995

in a one-to-one correspondence between institution and architecture.[4] Each archetype also puts a public face on the complex of relations of visibility and secrecy embodied in the built environment itself, with its walls, enclosures and open spaces. In this way, architecture literally constructs the nexus of relations of belief, identity (including gendered space) and hierarchy that install power by shaping the public and private life of a culture.

For almost half a century, however, we have been undergoing an epochal change in magnitude of what Hannah Arendt identified as the changing meaning of privacy and the household in her book *The Human Condition*.[5] The dimensions and strong demarcations that once clearly distinguished cultural forms from one another have become blurred with non-physical and ephemeral appearances. Once television screens entered formerly private and even secret places of the home, the function of the household was irrevocably blurred with that of the forum into a hybrid form that is neither public nor private. In another example, one contemporary American stadium type, the "superdome," has more in common with the semi-public spaces of malls and corporate atriums than with public architecture. Furthermore, the stadium event is no longer there for itself, but for television; even within the stadium, giant video display screens may compete for spectatorial attention with the same unmediated events simultaneously occurring on the field. In this way, the relations between public and private, mass and individual that architectural forms embody have been utterly trans-

18

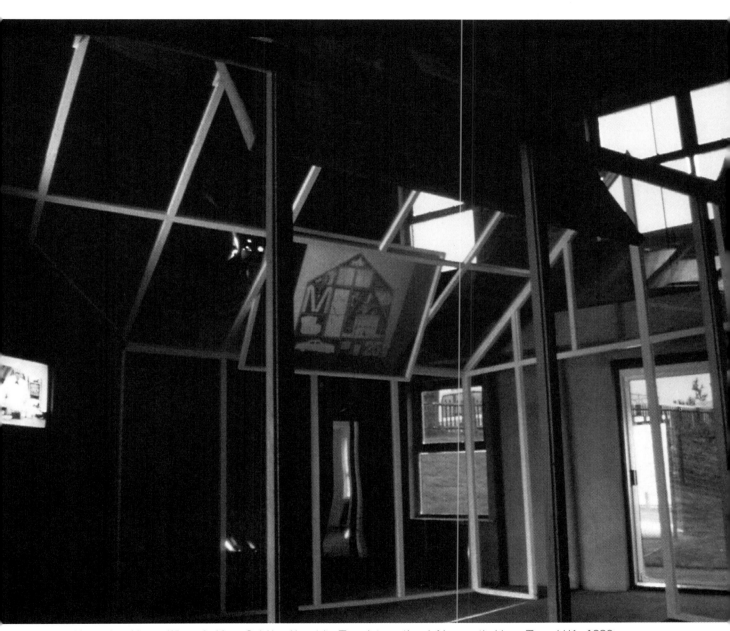

Muntadas. **Home, Where Is Home?** *A New Necessity*. Tyne International, Newcastle Upon Tyne, U.K., 1990.

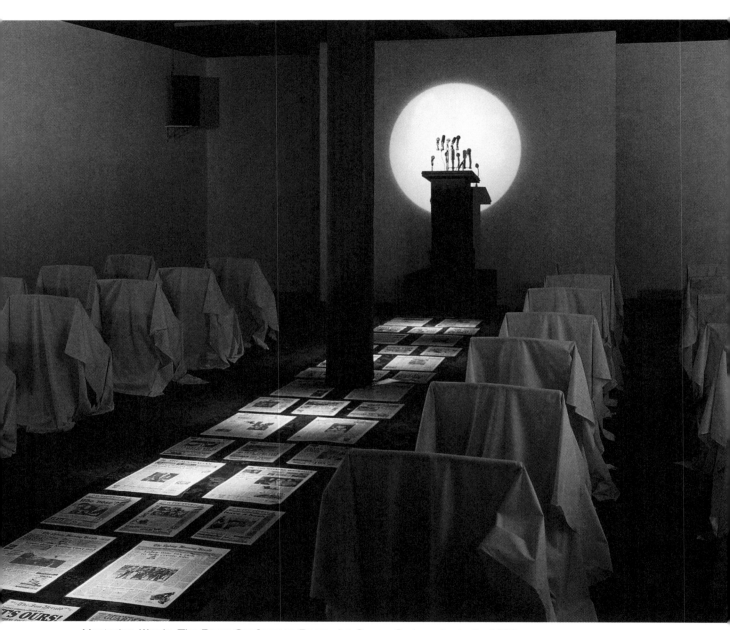

Muntadas. **Words: The Press Conference Room**. Art Space, Sydney, Australia, 1993.

formed by the media and telecommunications networks. Therefore, although media and architecture are joined with a hyphen in Muntadas' installations, as in our experiences of daily life, the media are an immaterial form of architecture that can contradict and derealize our material surroundings.

In light of this transformation, Muntadas' task of making the tacit and habitual dimension that frames human behavior and expectations in daily life explicit is more difficult than it might first appear. Pieces such as *Exposicion* (1985), *Exhibition* (1987), *The Board Room* (1987) and *Stadium* (1989)—recreated in different versions in cities from Banff and Santa Barbara to Valencia and Berlin—as well as *Home, Where Is Home?* (1990) and *Words: The Press Conference Room* (1991), suggest an incompletely rendered conceptual interior realm with a few well-chosen material objects, architectural and media elements and lighting—not the thing itself...or even a copy of the thing (especially since there may be no one model to copy). The maquette may be the most appropriate material label for such evocations of cultural forms. Walking through such a location of objects and representations, we quite literally experience from all sides the metaphor that is materialized in the installation, in an act that Walter Benjamin called "tactile appropriation." Benjamin also speculated that our relation to architecture—a mode of reception that is incidental, gradual and habitual—is especially significant when "the tasks which face the human apparatus of perception at the turning points of history cannot be solved by optical means, that is, by contemplation, alone."[6] Muntadas' installations reproduce the kinetic, tactile mode of architectural reception at one remove, making what automatically performs in daily life available to reflection.

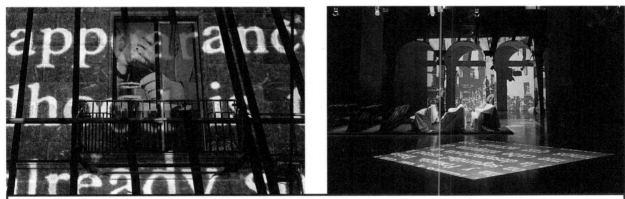

Muntadas. **Des/Aparicions**. Centre d'Art Santa Monica, Barcelona, Spain 1996 (details).

Peggy Gale has noted in her essay, "Muntadas' Eye: 1991," that while there were indicators of Muntadas' presence in his early videos of the 1970s—"an eye behind the camera or the hand holding the microphone"[7]—more recently Muntadas has absented himself from his art. One could say that he then left his position as subject behind the camera (and, subsequently, also as media-architect) unmarked and open so that the viewer could occupy it. (Others have pointed out the affinity between Foucault's notion of empty subject positions in cultural discourse and aspects of Muntadas' work.) In each installation, the powerful occupants of the chairs of *The Board Room*, the podium of *The Press Conference Room* and the electronic crowd in *Stadium* have abandoned their places, so that we can perform the piece.

Yet, we do not occupy a "position" comparable to the one from which a spectator could enjoy the illusion of Renaissance space in these media-architectural installations. Nor do we occupy the absences built into each installation for the phantom subjects of the "scene" to occupy. The visitor to the press conference room can't be addressed as "press"—that position is filled by the carpet of printed journals which occupies the floor in front. The seats of *The Board Room* offer no invitation to sit—the visitor might as well be a servant, until he or she is importuned by the evangelizing videos inside the paintings in an inversion of the "outside" and "inside" of this inner sanctum. The visitor to *Home, Where Is Home?* is homeless, without a place, much as its own inhabitants might be, shuttling between hearth and monitor. In *Stadium*, the viewer's path around a

series of central columns (within which an image of an ideal viewer is projected) lies virtually where the track for athletic events might be, in effect inverting the position of spectacle and crowd. Compelled to be mobile in order to view the spectacle of crowds on screens on all four sides, the visitor is an outsider, and hence privy to the open secret of the stadium and its cultural function—to produce crowds and "social glue." Indeed Muntadas' subtitle to *Stadium* is *Homage to the Audience*. The "outsidedness" to which the perambulating visitor is condemned is not a disavowal of the here and now or a lack of immersion in a scene that characterizes fiction; nor is it the reverie of a state caught between dreaming and waking. It is the wide-awake consciousness of the peripatetic.[8]

While each of Muntadas' installations is an environment, it is an open one; rather than containing us, each invites our thoughts beyond its limits. Fault lines and boundary violations are designed into each in order to point beyond to the world outside and to manifestations of the archetype in prior installations, modified each time and place in which the installation is sited. The archetype of the *Stadium* is expressed differently in Barcelona and Berlin, just as *On Translation: The Games* in the context of the Olympic games in Atlanta is quite different than its companion piece in Helsinki. Because Muntadas' installations are also often serial, one could say they unfold both in installments and simultaneously, each piece speaking to prior or co-temporal work in what is a cumulative dialogue with the next piece and the next—a kind of wide-ranging discourse on cultural forms.

Stadium: Placelessness and the Media Event

A geometrical (circular, rectangular, elliptical) form, an historical architectural construction, a container for mass events, a competition space, a location for spectacle, a set for media events, a device for entertainment and propaganda.—Muntadas, "Notes on *Stadium*"

Muntadas' Stadium series exemplifies the relation between media and architecture in his art. It highlights the derealizing effects that media events can have even on an apparently immutable archetype, undermining it as a locus and generator of identity and belief. *Stadium* invokes the sense of ambiguity and unease of the cultural form itself as an architectural framework that has been modified into a set for different moments in the production and reception of "media events." There is no "actual" media event present in each installation, only the uncanny images and sounds from recordings compiled variously from political, religious, musical and sports events in many different times and places in the 20th century. But, what sets the installation art event apart from the media events which it contains? Are the phantoms of past events any more or less real than the media events themselves? Furthermore, where do media events "take place"? As Daniel Dayan and Elihu Katz explain in *Media Events*, "There is still considerable ambiguity about whether 'public space' has not moved from the forum where it originated, from the theaters and stadia and churches, to the living room."[9]

The Olympics of 1992 provide a specific example of the ceremonial use of television, a spectacle or contest staged for a mass gathering in real space and in a definite place—for one, the historical Montjuic stadium in Barcelona, and forty-three other venues, including a soccer stadium in Valencia. It was, however, the radical transformation of that event by television, as received by millions of viewers in homes all over the world, that shall remain in our collective memory. I have discussed elsewhere the metamorphosis of sports on American television into something unrecognizable to a stadium-goer, via multiple viewpoints, extreme close-ups and slow motion replays.[10] Yet, the voices of narrators and the sound of a phantom crowd establish a shared realm which virtually joins the viewer at home with the ceremonial space of the stadium. As a result, the actual experience in either place is derealized in the process of what Dayan and Katz call "a quiet but powerful uprooting of the locus of reality."

> It raises the question of where the "real" event is actually taking place. Is it on the playing field chosen by the organizers, or is it in the air and at home?... If the broadcasters are not certain of the true locus of the event—coveting their free seats to the Olympics as much as others in the primary audience—we can't expect more from the home audience. There is a pervasive uneasiness, at least for those events that have some real locus, that one is missing out on something better. The in-person audience, it should be remembered, is also unsure about whether it should not be at home, watching TV. So are the organizers, for that matter.[11]

This derealizing process would be a trivial matter if the stakes of the cultural performances called media events were not ultimately societal integration. Namely, the spectacle which gathers anonymous masses under

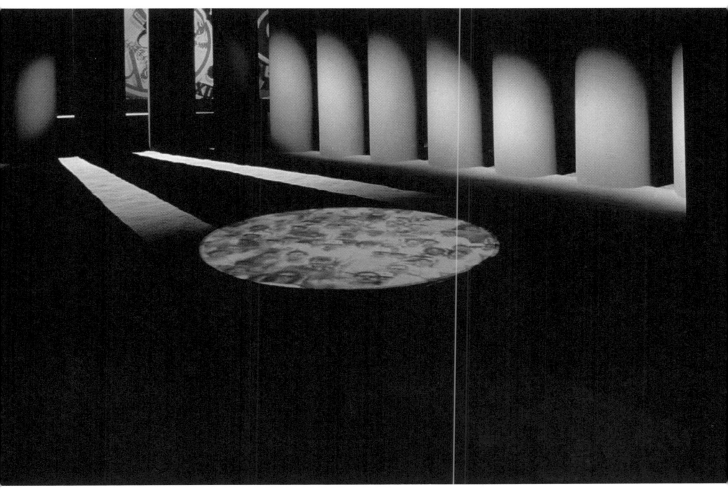

Muntadas. **Stadium VIII**. IVAM Centre del Carmen, Valencia, Spain, 1992.

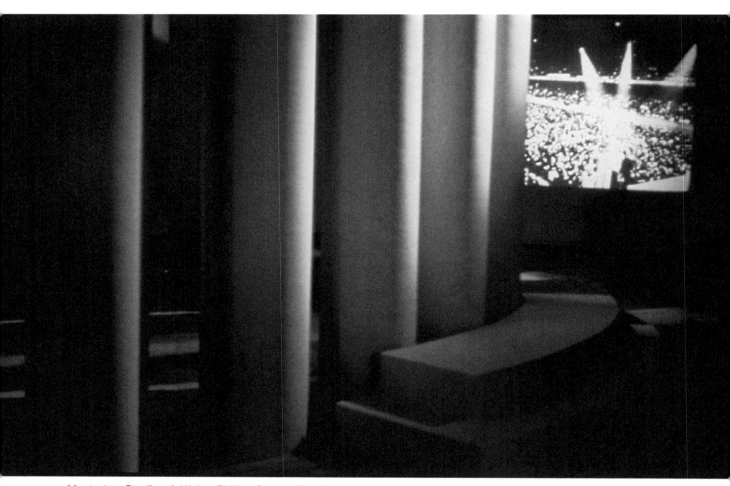

Muntadas. **Stadium I**. Walter Phillips Gallery, The Banff Center, Banff, Canada, 1989.

its spell, the orgiastic release of the crowd in the enclosed space of a stadium and emotional investment in charismatic leadership—the focus of cultural theorists from Walter Benjamin and the Frankfurt School to Guy Debord, Elias Canetti and Victor Turner—are all concomitants of identification with an entity such as "nationhood."

Of course, such "mechanical" means of fusion (as opposed to the organic bonds of family and community) are as dangerous as they are necessary to an "imaginary" unity, in the Lacanian sense, like "nation" or to collective notions of "man-" or "womanhood" or "self." The risks of such ceremonial and charismatic occasions for bonding might be exemplified in the historical link of Olympic stadiums in Berlin and Barcelona to the advent and legitimation of fascism.[12] In that sense, the return of the Olympics to Barcelona in 1992 was both a ceremonial recognition of the power of contemporary, modern Spain and a kind of closure of the era when nationhood was the primary or only identity to be validated by an event in which city, region, continent and, ultimately, the vast and virtually unified audience all over the world also played a role. The presence of the United Team as the ghostly and somewhat demoralized reminder of the Soviet Union was but a concrete and material example of a far more general destabilization of nationhood per se under the pressure of both pre- and post-national identities.[13] While national network television was once a vehicle of nationhood, VCRs and satellites now support local and post-national audiences. Meanwhile, television itself is in transition toward an immaterial cyberspace of an information society, or "non-space" unhindered by geographical location of any kind.

But we don't and never will live in a completely cybernetic environment, a purely informational city, imagined as a free-floating and utterly immaterial realm. Rather, the more urbanized and computerized of us live in an utterly hybrid situation, a mixture of decay, chrome and light, in both a specific historical and physical environment and a media environment in immaterial nonspace, which invites multiple and at times contradictory and unstable identities. Rather than recreating or simulating this situation in an ideal *scene*, complete with media event, Muntadas offered in *Stadium* an installation event in which certain techniques—the use of the existing or ready-made, the condensation of different spaces or times into one, the making and breaking of transparent "containers" of codes and cultural functions—are part of a repertoire of tactics to lift the peripatetic visitor out of an emotionally invested and enclosed situation, the better to contemplate it. Such strategic deployments occur in several of Muntadas' pieces.

Architectural Space in the Installation
One does not dwell in the metropolis; one passes through it between dwelling places.[14]

When, in the mid-1980s, Muntadas began to displace the built environment, ready-made and full-scale, into the gallery (like walking the forest to MacBeth), the results were apparently simple and easily apprehended by a visitor walking through the installation: here is, more or less, a board room, a stadium, a press conference room, a home. But on closer inspection, there is a remarkable architectural layering effect of the installation site, the in-stallation and the archetypal reference or subject matter ("board room," "stadium"). These layers work with and against each other in various ways to make the normally unperceived architecture of social life visible.

First, there is the *site or support of the installation*, the gallery itself. This architectural site was typically altered, for instance, by something as simple as opening windows wide at Centro de Arte Reina Sofia (Madrid,1988) or by incorporating a long-abandoned passageway which extended the installation beyond the gallery and into a nearby market in Muntadas' *Installacions/Passatges/Intervencions* at La Virreina (Barcelona, 1988). The latter installation also included the elevator between the gallery and other non-gallery floors, via the elevator sound system, which transmitted a mix of an 18th-century fandango with other sounds related to public spaces and architecture. All of these alterations not only opened up the site, they invoked other historical periods of its existence.

Another strategy was to install artifacts (or photographs thereof) associated with the prior use of a site—for instance, as a hospital (*Hibridos* at Centro de Arte Reina Sofia, 1988), a school (*Yesterday, Today, Tomorrow* at P.S. 1, New York, 1978), or a private home (*About the Public and the Private* at Serralves, Porto,1992)—making the gallery a temporal condensation, like a superimposition of past and present. So, the particular history and geography of a site, that is to say, its "deep-rootedness," also entered each piece in some way.[15] Consequently, the gallery was violated as a "container" for art, a tactic Muntadas calls *intervention*.[16] Alternatively, one could also say that the gallery was made too small for its contents and the installation itself spilled over beyond its container or site.

An inverse strategy of altering the gallery site is to implant "art" into the everyday—part of the interchange Muntadas calls *public interventions* into the non-equation art ⇄ life (for example, *Arte* ⇄ *Vida* at Barcelona, 1974, or the *Media Eyes* billboard in Cambridge, Mass., 1981). In *The Limousine Project* (New York City, 1990), the "gallery" was a stretch limousine—a mobile sign of power. The darkened windows of such conveyances allow the people inside the power to see without being seen; like celebrity sunglasses, they both announce and hide identity. *Limousine* speeding through New York's streets amidst the urban decay and gentrification of Manhattan would have been no different than a "ready-made," hard to differentiate as art or cultural commentary, without Muntadas' intervention of turning those darkened windows into screens projecting such loaded word combinations as *hidden ritual* and *mysterious corruption*. On the other hand, Muntadas' *Ville Musée* (Gallery Gabrielle Maubrie, Paris, 1991)—part of the project *City Museum* that also took place in Bruges, Barcelona and Brasilia—reinverted the relation art ⇄ life by addressing the uninvolved or disengaged way tourists relate to a city like Paris, as if it were a museum. "Paris" was put back into the gallery, where the virtual separation of the tourist and the city was made conscious as a problematic kind of voyeurism: peep-holes displaying touristic sights—or rather tourists photographing these sites—to the gallery visitor. In *New York: City Museum?* (The Storefront for Art and Architecture, 1995) the peep holes revealed a city that functioned less as spectacle than as a site for film crews engaged in the professional production of representations.

Another strategy, rather than altering the site or container or inverting its relation to the outside world, is to "frame" the gallery itself as a meta-art object—that is, to make it refer to its own cultural function, as in

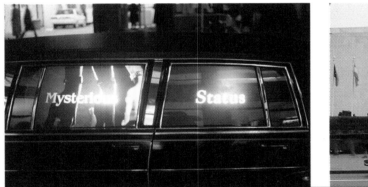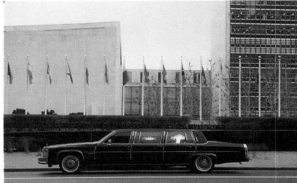

Muntadas. **The Limousine Project.** *Rhetorical Image*, New Museum of Contemporary Art, New York, N.Y., USA, 1990. Produced by the Public Art Fund.

the seminal piece and turning point toward architectural concerns in Muntadas' work, *Exposicion* (1985). As in *Exhibition* (1987), the gallery as an art "container" became apparent by an emptying out of the contents or subject matter of an installation of "prints," "drawings," "photos," a triptych, a 19th-century frame, a slide and film projection, a video installation and a billboard. All were "empty," nothing but light, in what was actually the display of a compendium of hanging practices and lighting conventions that frame art as "art."[17] The gallery itself thereby became an installation that was a transparent metaphor of itself and its productive power. The intervention here was not on the site, or even the installation, but in the absence of any representational subject, through a process of emptying or the absence of "art" work.

In other words, the second layer, the *architectural aspects of the installation*, was like an empty framework, which allowed both the gallery site and the archetype of "art" to become visible. Such absences are just one of a repertoire of effects which Muntadas uses to make the installation more and less than the thing to which it refers. Despite its life-size props, and the way the viewer is spatially surrounded, the installation is seldom a "scene" in which the visitor can be perfectly immersed, as if in a "real" gallery, a house, a stadium or a press conference room. Leave such hyperreal effects to theme park rides and virtual reality worlds! It is the incompleteness of the installation rather than a displaced "real" structure that reveals the concepts or metaphors which shape the material architecture. This Brechtian gesture reveals the mask as mask and the

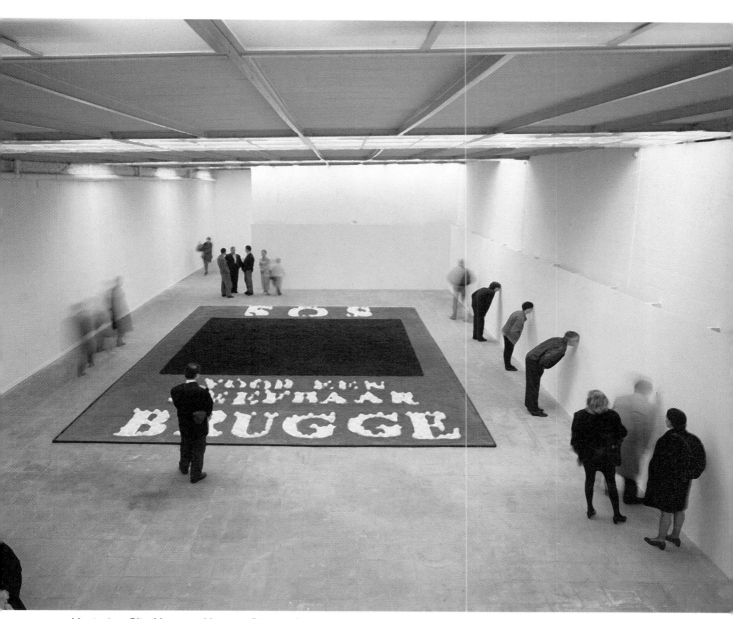

Muntadas. **City Museum: Museum Staadt**. Galeria de Lege Ruimte, Brugge, 1991.

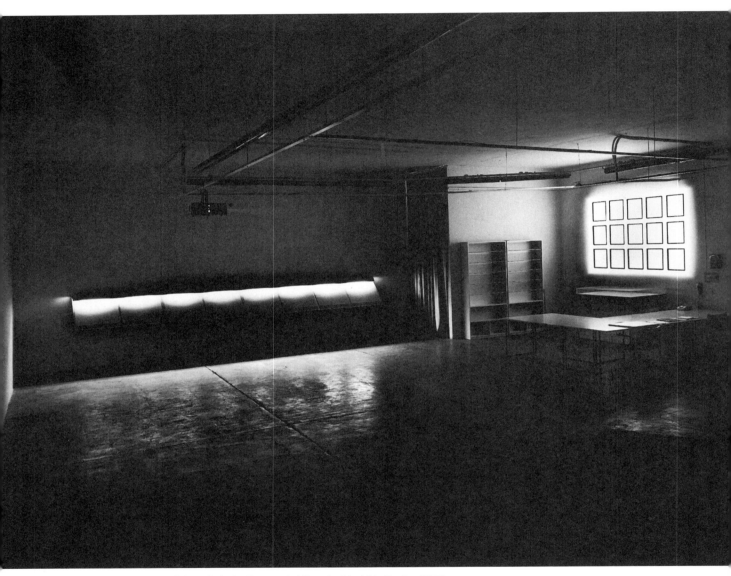

Muntadas. **Exposicion**. Galeria Fernando Vijande, Madrid, Spain, 1985.

architectural container as container, and its purpose is to keep the visitor resolutely removed from, albeit "inside," the installation.

The Board Room, on the other hand, is a complete and autonomous "scene," an enclosed space with a large conference table surrounded by thirteen chairs (as if for The Last Corporate Supper): mini-sized screens displaying the television appearances of thirteen religious leaders, from Jerry Falwell to the Ayatollah Ruhollah Khomeini to Rabbi Schneerson, are imbedded literally as "mouthpieces" in thirteen respective paintings which line the walls.[18] Here is a business with no product to exchange but faith in the word. Though the seats around the table are empty, by implication the absences are to be filled by such an implausible and incommensurable conjunction of world religious business leaders, whose recorded voices can be heard murmuring together, that the scene is clearly a metaphor realized. The obliqueness of this condensation and its unlikelihood in everyday space and time, where these religions espouse exclusivity and sole access to truth, is an intervention in metaphor as a kind of conceptual container.[19]

At this point, under architectural elements, we must paradoxically include the media themselves used in Muntadas' installations, from lighting to video. Muntadas' work has reflected ironically on the media landscape of billboard advertising (Media Eyes, 1981; This Is Not an Advertisement, 1985) and television since TV/27 Feb./1pm in 1974. However, media images also function as features of the built environment, like windows, walls and surfaces, or even "bleachers" for the crowds given homage in Stadium.

The sound design in Stadium is another kind of virtual architecture, "filling" the installation space with the characteristic reverberations and decay of the announcers' voices, of music and the roar of the crowd in

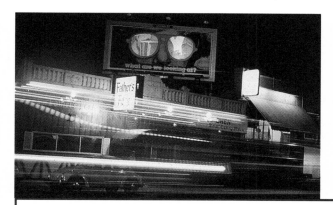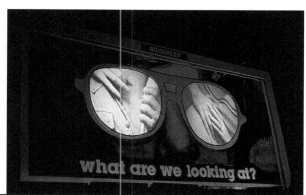

Muntadas in collaboration with Anne Bray. **Media Eyes.** Cambridge, MA, USA, 1981.

various phantom stadiums. Such sound designs "fill" The Board Room as well, while in The Press Conference Room phrases from speeches given to the press gradually overlap into noise. In everyday life, we have extraordinary capacities for discriminating such sounds and keeping cacophony at bay. Turning speech into noise is a manipulation comparable to the speed-up of images beyond the viewer's powers of comprehension in other pieces. Muntadas also employs the opposite strategy, slowing-down; in video, slow motion may be quite revealing, but also eventually degrades into "noise." Such cultural noise both conveys a sense of meaninglessness and "frames" or makes visible the materiality of language as a global envelope or net of sound that is also sensitive to time as a rate of motion and decay.[20]

This media architecture is part of an emerging information society, of which television is only the harbinger, that offers an utterly different and virtual way of relating to space as network.[21] Such counterintuitive and immaterial spatial *nets* co-exist with our most archaic needs for deep-rootedness and shelter: "The homes we create for ourselves are far more than physical shelters; the homeless lack far more than homes."[22]

These contradictory spatial fields are most obviously at the heart of an installation like Home, Where Is Home?, where two foci, the fireplace and the television set, compete for attention. In The Press Conference Room, the effect of the media is less to pose a competitive realm than to transform the once public forum into an enclosed and exclusionary site for the mediation of political, religious and other leadership by the press.

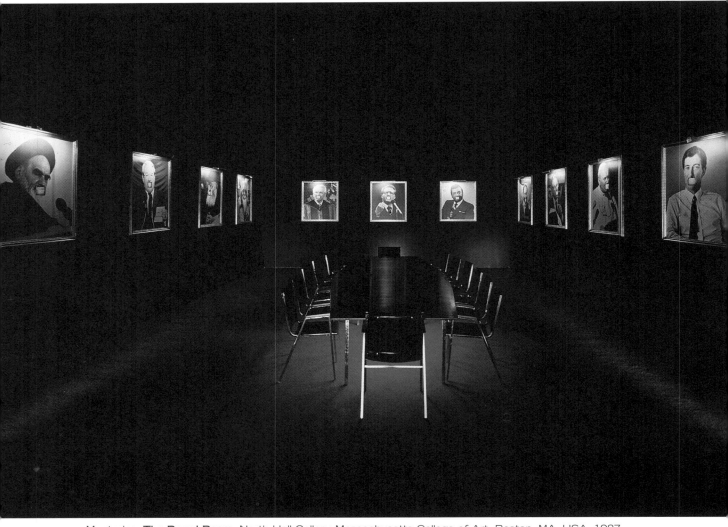

Muntadas. **The Board Room**. North Hall Gallery, Massachusetts College of Art, Boston, MA, USA, 1987.

Finally, the third or *conceptual layer*, concerned with the *architectural metaphor* and cultural function to which each installation refers, has already been mentioned—the art-producing function of the gallery, for instance, or the features that make up a stadium and its product, "the crowd." These are what Muntadas and others have called archetypes or genres. The notion of genre (*Generic TV, Generic Monument*, 1987) has long been part of Muntadas' work. For instance, in the video installation *The Last Ten Minutes* (1976-77) and the single-channel videos *Credits* (1984) and *Slogans* (1986), Muntadas has patched together evidence of global domination, not necessarily of contents or programs themselves, but of television formats and "packaging" conventions of largely American origin. Similarly, other "generics" (*Generic Still Life*, 1987) highlight the packaging of hybrid objects in which the functions of advertising commodities and displaying art are condensed. One might compare these generics with surrealist techniques of dream-work, in which random collations reveal a collective subconscious.

But, there is more at stake in this conceptual layer than illustrating or exemplifying a genre or collective idea. It is on this level that the visitor can become aware of the installation's self-reflection and commentary. Muntadas' pieces consistently point to this metalevel, in what is a rich tradition of the 20th-century art that includes Duchampian framing of "ready-mades" and Cubist collages of space-time. One way of doing it is to build discrepancies as well as commonalities into each generic piece and among pieces. In part because of this, meaning in Muntadas' work is not to be found in any one object or even in any one installation but in relations of commonality, overlapping and difference conceptually buried within and "in-between" them, and, literally, in the oblique and local ways in which such containers for collective ideas are broken, be it at the level

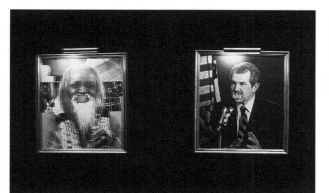

Muntadas. **The Board Room.** North Hall Gallery, Massachusetts College of Art, Boston, MA, USA, 1987 (details).

of the site, the installation or the archetype—or all of the above. Furthermore, this "in-between" is to be understood at a metalevel, in which the media, for instance, are used to investigate the very elements which construct the "media," or in which architecture is concerned with the very idea of itself.[23]

No wonder Muntadas has titled two of his pieces with "between"—*Between the Lines* (1979) and *Between the Frames: The Forum* (1983-92), which investigate the news media and art, respectively. *Between the Lines* contrasts a single-channel video documentary on the construction of a news story with a video installation deconstructing the resulting news telecast by breaking the news image frame into four fragments and projecting them separately, thereby degrading both image quality and information in another strategic instance of cultural noise. *Between the Frames* is a quite different and massive project. A series of eight single-channel videos, each explored one aspect of art during the period of strong commercial orientation in the 1980s. Rather than evoking any one institution as an architectural metaphor, the videos present the art world as a system that lies in the relations between various individual and institutional subject positions—dealer, collector, gallery, museum, to docent, critic and media—in discursive and economic exchange.[24] Interviews were collected from 1983 to 1989 and edited into seven chapters, beginning in 1990 at the Banff Centre and the Wexner Center for the Arts. These chapters were displayed, along with a reflective epilogue, in wedges in a circle, a kind

of reverse panopticon, according to Muntadas, in which the audience moving between sections edits the work.[25] Though the installation of *Between the Frames: The Forum* was somewhat disbursed, especially in the Wexner Center's spatially erratic and fragmented exhibition space, its elements remained in a coherent and proximate interrelationship or collective shape. However, in other manifestations, for instance, in Bordeaux, the elements were scattered throughout the exhibition site, much as they are scattered in life. Such distribution, or what Muntadas calls "exposing and exploding" the piece, has precedents in prior pieces—for instance, *haute CULTURE*, a series of installations from 1983-85, which began with an installation occurring in two different places at once, the Musée Fabre and the Polygone shopping mall in Montpellier.

The use of the printed and spoken word is common throughout Muntadas' pieces and is not only a reference to particular cultural discourses but another way of making the conceptual nature of his installations pointed and explicit. For any one piece, permutations of a concept or domain may be generated into a bank of words and shuffled into different combinations—for instance, as a single graphic over a video image, as in *The Board Room*, or as two words projected in changing syntactical relations, as with the two car windows of The *Limousine Project*. The graphic word over the video image of each one of the thirteen religious leaders in *The Board Room* is seemingly selected to emphasize a particular moment in each leader's personal speech, anchoring a particular truth of the image. However, the cumulative effect of the words common to all these leaders— all of which relate to money and power—highlights another kind of message about the institution of telereligion. Similarly, the spoken words in *Home, Where Is Home?* cumulatively reveal a cultural construction that is an existential necessity and wishful thinking; as an idea it can be dislocated and decentralized, like

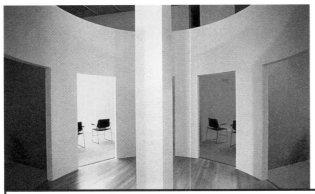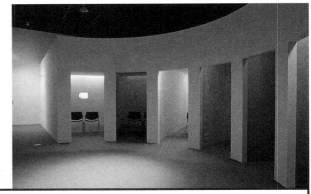

Muntadas. **Between the Frames: The Forum.** Wexner Center for the Arts, Columbus, OH, USA, 1994 (left); Vera List Gallery, MIT, Cambridge, MA, USA, 1995 (right).

Muntadas' nomadic pieces themselves. Similarly, the words of *Stadium* are selections from a paradigm of semantic variations on the theme of the stadium itself and its role in cementing a cultural identity—words like *stadium, circus, arena, amphitheater, dome, records, speeches, order, screams, rivals, winners, losers,* etc. These words appear singly and randomly over the four walls on which various crowds of sports, religious and music events are projected, again "anchoring" the meanings of an image—meanings which are paradoxically somewhat different, depending on how the deck of images and words is shuffled. But because words can change the meanings of images so randomly, the words also comment on their own role as print per se used to anchor ideas. This anchoring *and* self-commentating role of print can be found in many of Muntadas' single-channel videos and installations.

Muntadas' "in-betweens" can have a far more literal meaning than these conceptual and meta-level constructions at first suggest—they can open up a physical path for the visitor within and between them. The bridge between the conceptual and material levels of these media-architectural installations lies in the deep structure of corporeal experience, in much the same way that George Lakoff and Mark Johnson describe in their book *Metaphors We Live By*.[26] Consider the link between physical postures, metaphors and states of mind (from the waking dream of someone chained to a seat in the movie theater, to the rumination of conversation at a table, to the changing points of view of perambulation). This suggests that a particular wakened state of mind is fos-

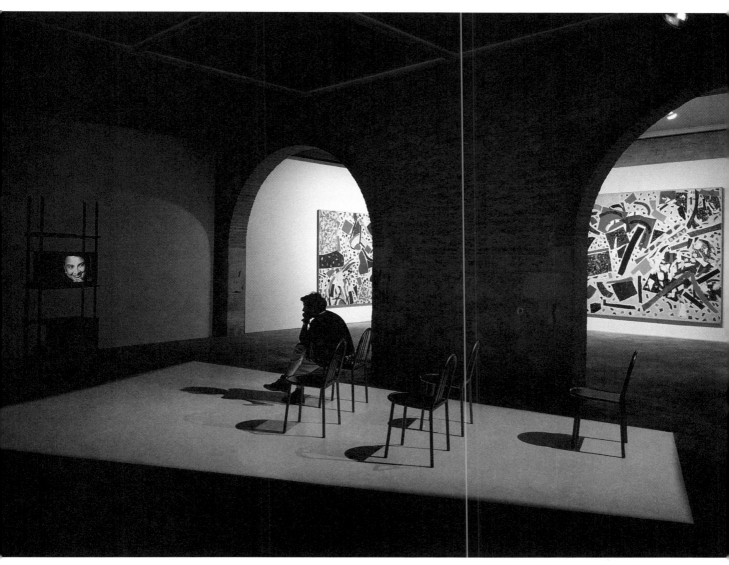

Muntadas. **Between the Frames: The Forum.** capc Musée d'art contemporain de Bordeaux, France, 1994 (detail).

tered by the very mobility that the media-architectural installation itself demands of a visitor. Furthermore, the installations draw on the corporeal experience of the world within which we live as a "container" largely invisible to us. The *container* is a fundamental metaphor, not just for architecture, or even such an ideological and collective social category as "nation," but for language and culture; indeed, many of the dichotomies which inform Muntadas' art—inside and outside, visible and invisible, public and private—are entailed by the container metaphor. Significantly enough, while Muntadas' installations do everything possible to make such metaphoric containers visible, they are also engaged in emptying or mixing hybrid contents, violating and opening them out or, generally, evading them at a higher level of reference.

On the other hand, the *net* and highway metaphors of our post-national information society are far less intuitive; they provide a disorienting experience of "non-space" which is not subject to manipulation. Perhaps this disorientation can best be countered at a local and material level. An early and delightful Muntadas sculpture of 1973, consisting of a file of drawers full of neighborhood smells,[27] can be considered a landmark of such counter-tactics, while the other localisms and historicisms of each installation, and their reverberations of decaying sound or cultural noise, are a way of pointing out alternatives to "non-space." The effort to render the virtual as well as the tacit visible and audible must be even more reliant on metaphor than forms which have analogues in physical space. Muntadas' *The File Room* (1994), one of the first original art pieces created for the internet and the World Wide Web, is a collective labor performed together with its audience that is dedicated to bringing acts of censorship by various groups and members of the public to light. Though the artwork has an address on-line in virtual space, it was also given material expression in an exhibition at Chicago's Randolph

34

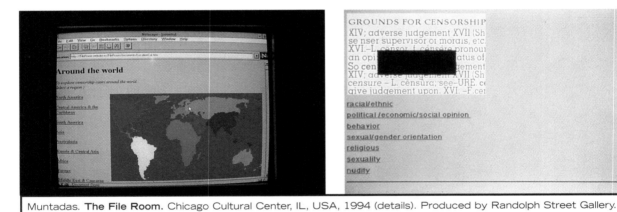

Muntadas. **The File Room.** Chicago Cultural Center, IL, USA, 1994 (details). Produced by Randolph Street Gallery.

Street Gallery in a room composed of a Kafkaesque surround of metal file cabinets. Like other media-architectural installations, *The File Room* offers the visitor a physical passage through intangible networks and the censored and hidden spaces of culture by means of a metaphor made material and available to sensuous understanding. *On Translation*, Muntadas' next effort to make the tacit and the suppressed manifest, will undoubtedly exhibit a compendium of similar strategies as it continues over the course of the series. Yet, the nomadic path through each installation itself will offer what can't be anticipated here and what must be experienced.

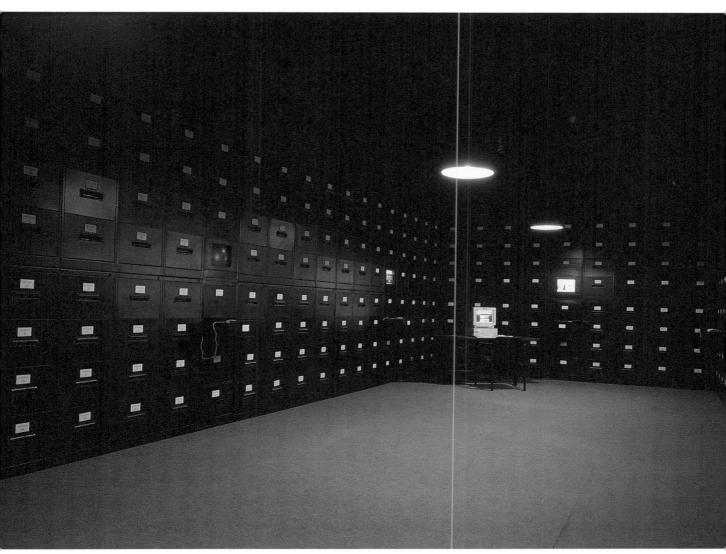

Muntadas. **The File Room**. Centre d'Art, Santa Monica, Barcelona, Spain, 1996.

1. Cited in Eugeni Bonet, "Muntadas: Deuxième tentative," in *Muntadas: chimaera monographie* 8 (Edition du Centre International de Création Vidéo Montbéliard Belfort, 1992), p. 6. Bonet has also written an insightful overview of Muntadas' artistic career ("Background, Foreground: Un trajecte per l'obra de Muntadas," translated as "Background, Foreground: A Journey through the Works of Muntadas," in *Muntadas a la Virreina: Installacions/Passatges/Intervencions*, trans. R. Rees and A. Mestres [Barcelona: Palau de la Virreina, Ajuntament de Barcelona, 1988], pp. 101-110) which goes beyond lucid description to offer commentary on the principles and strategies which inform his work. Peggy Gale's "Muntadas' Eye: 1991" is a brief but sure exposition of principles in a number of pieces in the catalog for the *Fourth Week of International Video* in Geneva (1991, pp. 23-25).

2. The alternative might be more like an experience I had in Poland of being translated after every sentence or two: at the end, the audience applauded the translator. Its reaction to her, a playful "you gave a nice speech," was probably closer to the mark than to presume complete equivalence with my original. In Muntadas' *On Translation—The Pavilion*, a long modular table with uneven legs propped up by dictionaries and grammar books in different languages suggests translation's function of leveling inequivalencies.

3. These ideas are particularly cogently expressed in Mikhail Bakhtin's "Response to a Question from the *Novy Mir* Editorial," in his *Speech Genres and Other Late Essays*, trans. Vern W. McGee, ed. Caryl Emerson and Michael Holquist (Austin: University of Texas Press, 1986), pp. 1-9.

4. See William J. Mitchell, *City of Bits: Space, Place and the Infobahn* (Cambridge, MA: MIT Press, 1995), pp. 47ff. He adds a point he explores at length in his book: "Today, institutions generally are supported not only by buildings and their furnishings, but also by telecommunication systems and computer software" (p. 49).

5. Hannah Arendt, *The Human Condition* (Chicago: University of Chicago Press, 1959). Arendt explained how the Greek citizen required the darkness of a household, within which women and slaves could generate the male public persona of the agora. It was the romantic period which utterly revalued the household as the sphere of interiority and subjectivity—and changed the values attached to femininity as well in the process. Perhaps what Virginia Woolf meant by "a room of her own" is this unobserved place of security and self-regeneration. Can privacy in this sense still exist when we are plugged into the network?

6. Such mastery of the world by touch can also influence optical reception. See Walter Benjamin, "The Work of Art in the Age of Mechanical Reproduction," trans. Harry Zohn and reprinted in *Video Culture: A Critical Investigation*, ed. John Hanhardt (Layton, UT: Peregrine Smith Books and Visual Studies Workshop Press, 1986), pp. 27-52.

7. Gale, "Muntadas' Eye," p. 25.

8. When I interviewed Muntadas in New York in 1989, I found his work central to understanding what media installation as an art form can do and provocative in formulating the idea of installation as a conceptual art in which a set of relationships are made manifest in objects. These insights were formulated in my article, "Video Installation Art: The Body, the Image and the Space-in-Between," in *Illuminating Video: An Essential Guide to Video Art*, ed. Doug Hall and Sally Jo Fifer (New York and San Francisco: Aperture and Bay Area Video Coalition, 1990), pp. 153-67.

9. Daniel Dayan and Elihu Katz, *Media Events: The Live Broadcasting of History* (Cambridge, MA and London: Harvard University Press, 1992), p. 76.

10. See my "Sport on Television: Replay and Display," in *Regarding Television: Critical Approaches—An Anthology*, vol. 2, American Film Institute monograph series, ed. E. Ann Kaplan (Frederick, MD: University Publications of America, 1983), pp. 44-66.

11. Dayan and Katz, *Media Events*, p. 76.

12. Background reporting on past Olympics tells the story of the Montjuic Stadium, built for the 1936 Olympics. Barcelona suffered the disappointment of having Berlin wrest the festival away. The unofficial Olympics held there for one day were interrupted by the coup that marked the beginning of the Spanish Civil War. Subsequently, the hill on which the stadium sits was used as a site for executing Catalan Republicans. The story of this stadium, even if the temporal conjunction of these events may not be completely accurate, suggests the powerful symbolism of the assertion and desecration of identity associated with the Olympic festival and with the built form of the stadium generally. (See C. W. Nevius, "Barcelona's Bitter Olympic Legacy," *San Francisco Chronicle* [20 July 1992]: C1, C2.)

The advent of Los Angeles as the most powerful city in the American West, rival to New York, was marked by its hosting of the 1984 Olympics, while the decline of my once dominant city, San Francisco—or at least its sensible civic disinterest in sport—was marked by the repeated refusal of voters to pay for a new stadium to prevent the sale of "its" baseball team to another market. (Recently, sport

power has shifted again, indicating another economic realignment as well.) The enclosed architecture of the stadium marks a liminal place, not only where contests are held but where transitions in the fate and fortunes of whole populations are marked, or at least invoked. Even the shape of the stadium suggests a closure, a mirroring division of self and not-self constituted in agonistic spectacle. This shape can also figure in the constellation of coercion, incarceration and annihilation—as, for one example, in Chili, when dissidents were herded into a stadium and eventually killed—though it is most often used to produce "social glue" via entertainment.

13. Other aspects of the Barcelona Olympics point to this instability from an American point of view: these Olympics were the first to openly abandon the ideal of amateurism in sports (allowing, for instance, the American basketball "dream team"), thereby opening the door for the dual allegiance of professional athletes to both nation and an athletic marketplace where bodies are commodities available to the highest bidder. Even the costly bid of the national television network, CBS, to broadcast the Olympics was an attempt to both halt its decline as a network in the face of the growing power of local, cable and post-national satellite distributors, and to thrust itself into an elite pay-per-view cable market with its triple-cast.

14. David Brodsly, *L.A. Freeway: An Appreciative Essay* (Berkeley: University of California Press, 1981), p. 39, and cited in my "An Ontology of Everyday Distraction: The Mall, the Freeway and Television," in *Logics of Television: Essays in Cultural Criticism* (Bloomington, IN: Indiana University Press, 1990), pp. 193-221.

15. See Alexandre Melo's application of the contrast between the anthropological conceptual models of "deep-rootedness" and "metropolitanism" to a Muntadas installation in his "Neither Public Nor Private," in *Muntadas: Intervenções: A Propósito do Público e do Privado*, exh.cat. (Porto, Portugal: Fundãçao de Serralves, 1992), pp. 69-111.

16. See an interview with Muntadas on his principles of intervention in *Kanal* 2 (Paris), (April/May 1992).

17. See Mary Anne Staniszewski's essay for *Exhibition*, exh.cat. (New York: Exit Art, 1987), n.p., for a history of display conventions in relation to this complex piece.

18. See Brian Wallis, "Born Again Architecture: Muntadas' *The Board Room*," reprinted in *Muntadas: Instal.lacions/Passatges/Intervencions*, pp. 98-100, for a discussion of televangelism in relation to this piece.

19. Muntadas reportedly planned to include representatives of power of all kinds in *The Board Room*, but to his credit drew away from what might have become reductively didactic or could have resulted in flat representations of metaphors or stereotypes.

20. *Transfer 1975*, a readymade video or training tape which was accidently substituted for his own work and framed by Muntadas as art, is another kind of cultural noise, much like the games Gossip or Telephone, where the message decays as it goes through many linkages and exchanges. That is, the translations behind the scenes which produce video are made evident in this "mistake."

21. However, an Australian aboriginal might feel right at home in the net, according to Urzula Szulakowska in her "Electronic Space in Contemporary Australian Art—Practice and Theory," in *Leonardo 24: Special Issue on Connectivity* 2 (1991): 167-70.

22. Mary Catherine Bateson, *Composing a Life* (New York: Penguin, 1990), p. 119.

23. Perhaps the resistance critic Eugeni Bonet has expressed toward Muntadas' self-characterization of his work as falling between art and communication (which I understand, for one thing, as the media environment) might be relaxed when that "between" is understood at a metalevel. See Bonet's essay in *Muntadas a la Virreina*, p. 110.

24. See Gale, "Muntadas: Working Between the Frames," in the catalog for the *Fourth Week of International Video* in Geneva, pp. 61-64.

25. See Muntadas, "Notes on *Between the Frames*," in *Muntadas: Between the Frames: The Forum*, exh.cat., ed. Debra Bricker Balken and Bill Horrigan (Wexner Center and the List Visual Arts Center, 1994), p. 15.

26. George Lakoff and Mark Johnson, *Metaphors We Live By* (Chicago: University of Chicago Press, 1980). Christian Metz's very useful distinction between metaphor (a mix of incongruent referential domains) and condensation (a mix of objects) is not so much abandoned here as referred to a level of bodily experience where the two are as one.

27. Gianfranco Mantegna's first question in his interview with Muntadas (*The Journal of Contemporary Art* 5, no. 1 [1990]: 77-87) concerns this smell file.

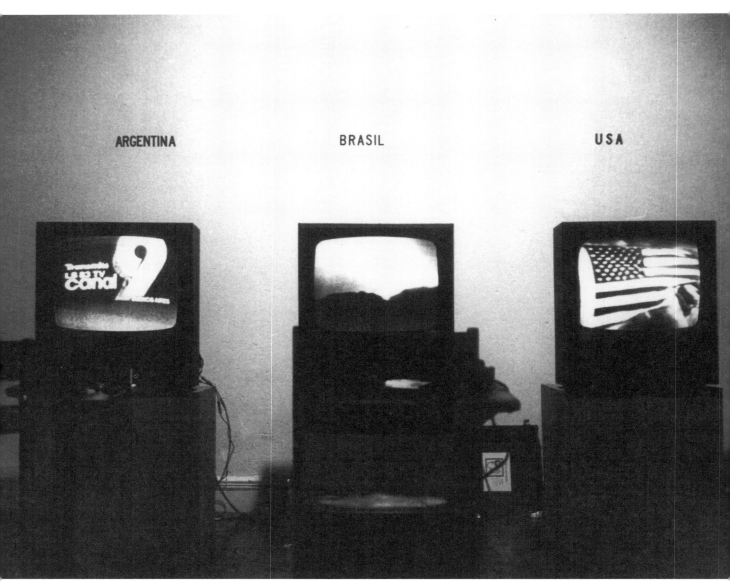

Muntadas. **The Last Ten Minutes, Part I.** Video installation at The Kitchen, New York, N.Y., USA, 1976.

Architectures of Information: The Video Work of Muntadas

CHRISTOPHER PHILLIPS

In a videotape portrait made by Boston's WGBH-TV in 1982, Antonio Muntadas describes himself as an artist who uses video, publications and installations to materialize his work. For more than two decades this work has consisted in large part of a sustained reflection on the mechanisms, both visible and hidden, of global mass communications. Yet Muntadas insists that he is not a professional media analyst but an artist who employs the findings of media analysts.

To examine Muntadas' video works in separation from his other production could be seen as a questionable procedure, since the various components of his work—books, catalogs, postcards, installations, videotapes, audio CDs—are clearly facets of a larger whole. Video, for example, has been a recurring and integral element of his installations since 1974; in that year, in *Confrontations*, Muntadas juxtaposed documentary video footage shot in the streets of New York with broadcast TV clips. Moreover, he has frequently used video as a way to document his public projects—for example, *This Is Not an Advertisement* (1985), a short "video verité" documentation of a work that Muntadas made for display on the Spectacolor electronic billboard in Times Square.

Nevertheless, the video works of Muntadas are complex and compelling enough to deserve consideration in their own right. They provide, in particular, a valuable key to the thematic concerns and the formal operations that have occupied him throughout his career. His video works, for example, can be considered "architectures of information" that are situated at the formal poles of extreme simplicity and extreme complexity. Some works consist of a disarmingly simple ordering of appropriated mass-media material; others overwhelm the viewer with a torrent of seemingly random visual citations from a vast array of sources. Muntadas has explained, "I am interested in the range *between* two extremes. I want the audience to see the spectrum and to locate themselves within it."[1]

The trajectory of Muntadas' video works from the early 1970s to the present takes us from an examination of the phenomenology of the senses to questions of social communication. Muntadas has been consistently fascinated by the variety of perceptual, technical and social apparatuses that "translate" everyday experience into communicable, understandable forms. Nonetheless, whether he is investigating the immediacy of "tactile environments" or the abstractions of the global image environment, the underlying question that he asks remains the same. How do we come to learn about the world and locate our place in it?

Beneath the Senses: The Video and Film Works of the Early 1970s

Born in Barcelona in 1942, Muntadas attended a Jesuit-run high school before studying architectural engineering at the college level. As a counterpoint to what he describes as the "rationality of engineering," he simultaneously began painting around 1962. It was only at the end of the 1960s that he found himself dissatisfied with the static quality of the painted image, and also impatient to find a way to reach a public wider than that offered by the existing gallery circuit. Although he moved his primary residence to New York in 1971, Muntadas was active as a member of the Barcelona-based Grup de Treball (Work Group) from 1973 to 1975. The group, which included Antoni Mercader, Francesc Torres and Pere Portabella, joined Conceptualist attitudes to a concern for the political and social issues which occupied Spain as the authoritarian era of the Franco regime reached its close.

Around 1970 Muntadas abandoned painting and began to use Super-8 film and video to document the artistic "actions" that he devised. Unlike a figure such as Nam June Paik, Muntadas has never specialized in video as a self-contained art medium. Instead he began as a "general artist" who utilized video as an effective way to convey his ideas to a wide public, and gradually developed a sophisticated command of the intricacies of the medium. He has said, "The choice of video was a completely practical thing. I was using video purely for the documentation of events, which is what really mattered to me. . . .The 'actions' were private and became 'public' through media."[2]

The first films and videotapes carried out by Muntadas in Barcelona and New York during the early 1970s investigate the ways that we learn to orient ourselves physically, mentally and socially in "sensory microenvironments."[3] One of the earliest of these works, *Collective Experience No. 3: Smell, Touch, Taste* (1971), presents 13 people, all wearing blindfolds, who gropingly explore a large walled-in space; the participants encounter a variety of sculptural elements which they investigate by means of the "secondary" senses of smell, touch and taste. *The Skin and 20 Materials* (1972) offers a different lesson in the materiality of the senses. We see a tightly framed image of a woman's bare back, which serves as the "canvas" to which a variety of substances are applied by the hands of an unseen collaborator. Various creams and liquids quickly disappear into the skin, leaving no trace; more solid, herb-like materials retain their physical identity despite vigorous rubbing.

Subsensorial Actions (1971-72) is a four-part work that Muntadas described at the time as "a voyage through the senses." *Subsensorial Actions 2* begins with a view of a studio arrangement that consists of 20 or so

Muntadas. **Actions 1**, 1972. Stills from videotape.

paper plates set on a red ground. In the center of each plate is a small mound of an unidentified substance. We see Muntadas, blindfolded and wearing overalls and a white shirt; he picks up each plate and examines the substance—smelling it, handling it, rubbing it into his face. In a later segment of the tape, we see his hands against a yellow backdrop as he handles tiny objects of varying textures and consistencies. The piece ends on an uncomfortable note, with a close-up of a finger into which a piece of sharp, shiny metal is being insistently pushed.

The black-and-white video *Actions 1* (1972) presents five short vignettes staged for the camera. Each episode involves one or more visual metaphors that refer to the basic aims of artistic activity: the transformation of material and the communication of a message. In the section called "Transformation," we see a kneeling figure whose hands move sensuously over the surface of an elongated Mediterranean fruit, then squeeze it so that liquid flows out, then open its skin and fleshy interior. In "Friction," we see a close-up of a hand holding something that at first resembles a potato and aggressively rubbing it with a small pointed instrument; the source of the vague discomfort that the sight produces is revealed when we discover it is a human foot that is being worked on; the segment ends with a close view of the foot with distinct striped marks. Most of the segments are staged on modest sets and feature dramatic theatrical lighting that underscores the artificiality of the actions.

From such works which concentrate on the way that the physical world is translated to the individual through his or her senses, an awareness of the wider social dimension begins to emerge in Muntadas' videotapes of 1973-74. *Markets, Streets* and *Stations* consider not only the different sensorial aspects of public spaces in Spain, Portugal, Morocco, Mexico and the U.S., but also the gestures and behaviors of the people who frequent these places. This attempt to analyze the different national codes of cultural communication set the stage for a significant change of direction in Muntadas' work.

From the Bodily Landscape to the Media Landscape

The 1972 installment of <u>Documenta</u>, the international art exhibition presented once every five years in Kassel, Germany, signaled that Muntadas was hardly alone in his growing preoccupation with the mass media. Titled *Questioning Reality: Image-Worlds Today*, *Documenta V* set out to explore the full range of contemporary imagery, both artistic and non-artistic. In addition to painting and sculpture, there were also sections devoted to film, video, performance, body art, photojournalism, political posters, magazine covers and science-fiction illustration. The show's organizers meant to assess the elusive dialectic of image and reality in the contemporary world, and to ascertain the consequences of the global proliferation of mass-media images.

For Muntadas, the challenge of learning to decode the "unknown language of images" that is met at every turn in the modern world led as early as 1974 to the video installation *Confrontations*. Presented at New York's Automation House, whose exhibition space was run by Billy Klüver of E.A.T. (Experiments in Art and

Muntadas. **On Subjectivity (About TV)**, 1978. Still from videotape.

Technology), *Confrontations* employed three monitors to present video images that compared physical locations (Canal Street, 14th Street and 42nd Street), entertainment films from three decades (the 1950s, 1960s and 1970s), TV news broadcasts and commercial TV programs from three New York stations. In addition, to suggest a "confrontation" between the still photographic image and the moving video image, three projectors were used to throw onto a gallery wall opposite the monitors enormous slides that examined the same themes. To prepare another 1974 installation at Automation House, *T.V./27 Feb/1 p.m.*, Muntadas sent letters to acquaintances in different parts of the world, asking them to send to him one hour of commercial television videotaped at the same hour in their respective countries. The resulting piece involved eight monitors which simultaneously played tapes of broadcasts from the U.S., England, Venezuela, Japan, France, Canada, Switzerland and Germany.

From this point Muntadas more often than not referred to himself as a "media artist." As he once explained to an interviewer, for him the term has two implications:

> One is the transition from traditional means of expression to experimental tools such as video, installations, and publications. The other side is the focus of the work itself, which is the media itself. The media artist works with systems of communication which are in close relation with social systems.[4]

In 1977 Muntadas' exploration of the mass media's image empire took an important turn when he embarked on an extended residency at MIT's Center for Advanced Visual Studies. One of the first products of that residency was *On Subjectivity (About TV)* (1978). This remarkable 50-minute work investigates the way that broadcast television seems to shape the parameters of individual and social perception, establishing the categories through which we experience and understand the world.

The tape opens with a shot of a TV set on the floor of an empty studio. From the TV we hear news-show reports on Boston's famous blizzard of 1978; the tape then cuts to video footage shot through the windshield of a car moving though snow-covered terrain. What follows is a barrage of rapid-fire clips taped from broadcast TV: a pitch for the fundamentalist *700 Club*, ads for a plethora of products, a speech by President Jimmy Carter, local news reports of a fire, football games, boxing matches, basketball games, sci-fi movies, national news shows and old Westerns. These clips alternate with studio segments that feature a group of educated, critically minded respondents who comment on the power of television. A woman's exasperated voice is heard over news footage: "Somebody else chose the picture. Somebody else created the sound. All right, I can turn it off, but then I have to remove myself from it entirely. What would happen if I just turned off the sound and looked at the pictures? Would that help?"

Interspersed throughout the tape are Muntadas' own fleeting references to the history of art and cinema. The superimposed image of a human eye and a camera's lens is an homage to the Soviet avant-garde docu-

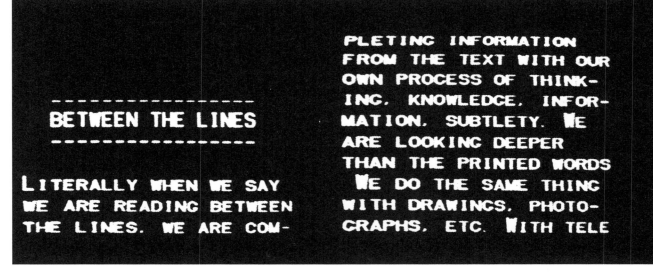

mentary filmmaker Dziga Vertov, who used a similar motif to suggest the merger of human perception and camera vision in *The Man with the Movie Camera* (1928). A split-screen image in which two people stand facing one another in the studio, each holding a camera and slowly zooming in on the other, is a nod to Michael Snow's experimental photo-book *Cover to Cover* (1975). Close-ups of dictionary entries for the words "objective" and "subjective" bring to mind Joseph Kosuth's mid-'60s Conceptual works involving photostats of dictionary definitions. *On Subjectivity* ends with the visual static that follows a TV station's sign off: this electronic "snow" punningly cycles us back to the blizzard with which the tape began.

A more stylistically straightforward video work of 1979, *Between the Lines*, offers an in-depth consideration of the way that television news programs filter and reshape the events on which they report. In this piece Muntadas himself appears on screen as a kind of critical investigative reporter, interviewing a black woman reporter who works for Boston's WGBH-TV. We see Muntadas and the reporter in her cluttered office discussing a story she has covered—a public meeting held by Boston mayor Kevin White with a predominantly black community group. We see the reporter selecting footage with video technicians, assessing the news value of the story with her editors, and taping an audio introduction to the piece. Muntadas carefully portrays the complexity of the process and the way that a number of specialists each contribute to the final on-air segment. In the end, we see how a two-hour public event is reduced to a roughly two-minutes news item.

In her own comments on this process, the reporter, self-aware and articulate, presents herself as a spokesperson for a minority viewing audience; in her broadcast item she carefully inserts a skeptical remark about the mayor's "glibness." But she offers no critical perspective on the flattening tendencies of TV news itself. She only observes, "The problem is, with television you have to think visually, and you may not always have the pictures to go along with what you're saying." With exquisite tact, Muntadas shows that it is not only the viewers of television who are prevented from reflecting on the medium's rapid flow of information. Even the news professionals who supposedly direct the process are shown, in the end, to be its helpless prisoners. Here Muntadas already introduces the idea that shaped his examination of the 1980s art world, *Between the Frames*, completed in 1994: the notion that professional discourse is among the most powerful of the "invisible ideologies" that short-circuit critical perception.

The Esthetic of Objective Information

The critic Dore Ashton has pointed out, "As an artist, Muntadas understands that. . .objective data orchestrated to infuse the senses of his viewers with slowly gathered and recombined insights is the most effective technique for instigating critique."[5] One of Muntadas' most characteristic and effective techniques in his video works is to collect and represent, without commentary, mass media materials in such a way that they become truly "readable" for the first time. An early example of his use of this approach can be found in his installation *The Last Ten Minutes*

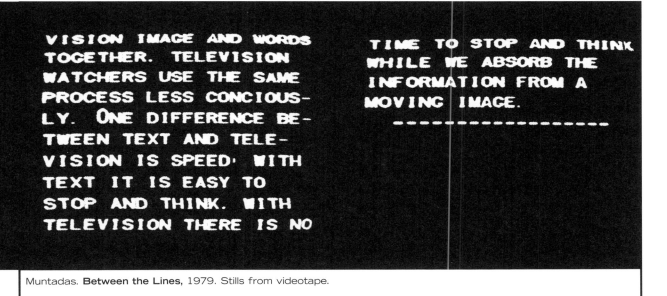

Muntadas. **Between the Lines,** 1979. Stills from videotape.

(1976-77), which incorporated unedited videotapes of the closing ten minutes of TV programs from three different countries; these segments were intercut with footage of urban passersby shot in the same three countries. In its first version, presented in New York at The Kitchen, the comparison of material from the U.S., Brazil and Argentina revealed the dependency of Latin American media on televisual forms devised by U.S. media. The second version, prepared for *Documenta VI* in Kassel, Germany, juxtaposed broadcast programs and street footage from the U.S., West Germany and the Soviet Union.

Credits (1984) extends this idea to a global scale, demonstrating that by highlighting overlooked areas of media content, new perspectives can be opened onto the general structure of the media system. *Credits* consists of 25 minutes worth of "televisual wallpaper": closing credit sequences from a wide variety of TV programs—talk shows and educational programs, sports spectaculars and news broadcasts—strung together one after another with no additional commentary.

Confronted with this material, the viewer is initially irritated; after all, the appearance of closing credits usually means that it's time to change the channel or head for the refrigerator. Quickly, though, one realizes that this is a kind of broadcast "filler" that is seldom watched carefully. Muntadas assumes that his audience

will be curious enough to respond analytically, and to begin to identify the elements that structure the format of the credit sequence. These include scrolling lists of specialized technicians; underlying visuals, whether still images, narrative clips or live in-studio scenes; theme music, from bouncy Las Vegas pop to solemnly classical; and deep-voiced announcers bringing word of upcoming programming. What emerges most dramatically from these accumulated sequences is a sense of the complexity of the system that produces them. The credits indicate not only stars, producers and directors but also a host of supporting technicians: carpenters, graphic designers, electronic title designers, wardrobe directors, narrators, "hair designers," camera operators, lighting consultants, casting directors, music composers, music editors, choreographers, special-effects consultants, stunt coordinators, writers, script supervisors, animation specialists and "skin care specialists." By foregrounding the typically unnoticed information that is conveyed in the closing credits, Muntadas makes us conscious of the complex social organism that generates mass media programming.

Using a slightly more elaborate method, *Slogans* (1986) zeroes in on advertising slogans, revealing the underlying similarity of the many lures that are used to deliver a "captive audience" to advertisers. Over a banal visual backdrop—scenes from nature, then neutral monochrome fields—short advertising slogans appear: Pleasure by Design, Reach a New High, Leave the World Behind, For Once in Your Life the Very Best, Share a New Adventure. One key word of the slogan is briefly isolated on the screen before it is transformed by a pastel-colored "abstract" computer graphics design. In the background we hear easy-listening versions of familiar pop songs from the 1930s and 1940s. Ending the work on an ominous note is the tune "Life Is a Cabaret," with its allusions to Weimar Berlin and the onset of totalitarian rule.

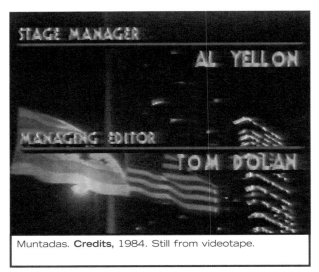

Muntadas. **Credits**, 1984. Still from videotape.

Muntadas. **Slogans**, 1986. Still from videotape.

Cross-Cultural Television (1987), which Muntadas made in collaboration with Hank Bull, is ironically titled. Although "cross-cultural" leads us to expect a survey of diverse programming from around the world, what we get is an astonishing demonstration of the global standardization of televisual forms and the way they serve to erase cultural difference. The work begins with a series of test patterns and color bars from stations in Japan, Spain, Australia, Thailand, Hong Kong and elsewhere. Jumping rapidly between first-world and third-world countries, we see virtually identical introductory visual sequences from TV news shows around the world: stirring music and computer graphic images of spinning globes and outlines of national maps. In a host of sleek studio settings, we see a succession of telegenic newscasters greeting us with stylized gestures and carefully modulated voices. Intermittently a cluster of words crawls across the screen, alerting us to the unspoken principles that guide commercial telecommunications: *Speed—Time—Money, Media—Colonisation—Star, Rates—Control—Exchange, Subliminal—Format—Value.*

Symbolizing the Media Landscape

Because of the wealth of information they contain as well as the clarity of their structure, it's possible to imagine *On Subjectivity, Between the Lines* and *Cross-Cultural Television* being presented in a college class on the sociology of

mass media. Other of Muntadas' video works, however, offer more distanced and formally sophisticated meditations on similar themes.

Watching the Press / Reading Television (1980-81) is a kind of symbolic distillation of On Subjectivity and Between the Lines. Under the ominous sounds of the Marianne Faithfull's "Broken English," we see various fragmentary images that refer to the experience of being a media consumer. We follow the camera as it moves slowly, in close-up, around the edges of the TV monitor, forcing our attention to the "frame" of the images that are transmitted. We see the covers of magazines like People, Money and U.S. News and World Report and close-ups of iconic advertising figures like the Marlboro Man. Looking over the shoulder of a reader who flips quickly through the pages of these magazines, we fleetingly glimpse familiar-seeming but not quite recognizable images and typography. From this rapid succession of individual pages and layouts, something like the generic graphic language of mass communication takes shape before our eyes.

Even more abstracted allusions to the media experience are found in Media Ecology Ads (1982). The video work consists of three short segments, each based on a minimalistic image that suggests an unstoppable and irreversible movement in time. The first is a fuse that burns from left to right across the screen, the second a sand clock whose grains run down the center of the picture area, and the third a faucet spewing water at faster and slower speeds. Each of these images is accompanied by a synchronized flow of text. The faucet, for example, is flanked on either side by a flowing column of words which suggest Muntadas' idea of the hidden principles that govern the flow of images in the media landscape: Back—Myth—Forward—Dreams—Fake—Market—Real.

Muntadas in collaboration with Hank Bull. **Cross-Cultural Television,** 1987. Stills from videotape.

Video Is Television! (1989) is one of the most visually dense and conceptually arresting of Muntadas' video works. The title refers to the claim that "video is not television," long made by video artists who insist that their work exists in a realm separate from that of broadcast television. Video Is Television! challenges that assertion, uncovering the shared visual language that runs through feature films, broadcast TV and video art. As a droning sound track by composer Glenn Branca gradually accelerates toward a pulsating crescendo, we see a rapid montage of clips from a wealth of sources: feature films like Blade Runner, Videodrome, The Man Who Fell to Earth, Hairspray and Fellini's Ginger and Fred; and video art pieces like Martha Rosler's Born To Be Sold, Max Almy's Lost in the Picture and Muntadas' own On Subjectivity. These clips are virtually unrecognizable, however, for many appear as intentionally blurred images or close-ups of scan lines and three-color dots. Superimposed over these fragmentary images runs a sequence of Muntadas' key words: Video—Film—Television—Image—Fragment—Excerpt—Manipulation—Context—Audience—Ratings—Content—Generic.

Video Is Television! ends with the camera pulling back from a single screen to reveal the interior of a consumer-electronics store, with row upon row of video monitors showing the same image. This overall shot is then itself frozen and digitally multiplied, over and over, within a grid format. Muntadas' closing sequence imagines mass media imagery to be a kind of cancerous growth that has spiraled utterly out of control. At the end, we are sitting astonished before a gray, neutral screen.

Muntadas. **Media Ecology Ads,** 1982. Stills from videotape.

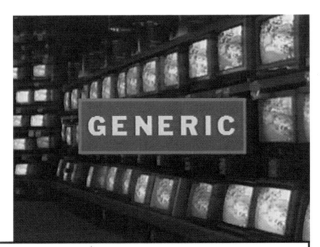

Muntadas. **Video Is Television?,** 1989. Stills from videotape.

Some of Muntadas' most striking video works illuminate the way that the growth of mass communications has irreversibly altered political life in the years after World War II. *Political Advertisements* (1984, updated in 1988 and 1992), made with Marshall Reese, starts from a commonplace observation—that American political candidates are marketed like commercial products—and goes on to show in startling detail exactly how this has come about. It consists of a sequence of TV spots, presented without commentary by the artists, promoting presidential hopefuls from Dwight Eisenhower in 1956 to Bill Clinton in 1992. The result, simultaneously hilarious and chilling, is a capsule history of the evolution of television style. It takes us from the minimalist purity of Eisenhower seen alone in a bare TV studio, heartily addressing his invisible audience, to the infectious jingles and rapid-fire editing of John Kennedy's 1960 ads, to Ronald Reagan's cynical, Hollywood-slick "morning in America" spots of 1984.

Not surprisingly, many of these political spots feature mind-numbing campaign slogans of the sort we've encountered in Muntadas' earlier *Slogans*: "Nixon's the One," "I'm Feeling Good about America" (Gerald Ford), "Why Not the Best?" (Jimmy Carter) and "Standing Tall" (Ronald Reagan). *Political Advertisements* confirms that, at bottom, campaign advertising speaks the language of advertising in general: an idiom of persuasive communication to which the public has been trained to respond.

TVE: Primer Intento (1989) deals with the interweaving of mass communications and cultural politics in a more evocative way. The work was originally commissioned by a program called "Metropolis," a presentation of the Madrid-based, state TV network TVE. Granted access to the visual archives of TVE, which was long

Muntadas in collaboration with Marshall Reese. **Political Advertisements,** 1984 (updated in 1988 and 1992). Stills from videotape.

47

the single TV network in Spain (private networks have now been introduced), Muntadas and two teams of researchers immersed themselves in the project for two years.

Muntadas found himself startled at the chaotic condition of the TVE archives—a vast collection of films and videotapes containing images that form a crucial part of what he calls the "memory of the country." At one point we see what at first appears to be an auto-filled parking garage, but as Muntadas's camera moves with intentional slowness through the space to reveal shelves piled high with boxes, we see that the garage is also one of the many sites to which portions of the TVE archives have been haphazardly dispersed.

In its completed form *TVE: Primer Intento* mixes archival film and video images with present-day footage shot by Muntadas to convey the dramatic changes that have swept Spain since the 1950s. It begins with a color test pattern, then "flashes back" to a black-and-white test pattern from the 1950s. We see Spain's long-time authoritarian ruler, Gen. Francisco Franco, seated stiffly behind a desk, assuring the public that the corrupting influence of Western media will never penetrate "our fortress." We see the opening credits of news programs, as well as footage of historic national events and scenes of striking workers and demonstrations. Finally we are taken to a trash dump filled with scrapped TVE trucks and spilled video reels—the scrapped vestiges of

the nation's memory. At the end of the work Muntadas presents a sequence of TVE sign-off segments from the 1950s to the present. In them we can glumly follow the replacement of one national icon of authority, Franco, by another, King Juan Carlos, whom see growing older, sterner-looking and increasingly partial to military uniforms.

The final version of *TVE: Primer Intento* was never broadcast, and Muntadas was never given an official explanation for the refusal of TVE to show it. The producers of "Metropolis" were sophisticated enough to allow him to present the piece to the comparatively small audiences that frequent galleries or museums, but also to forbid its originally envisioned public broadcast. Muntadas regards this instance of censorship as the seed of his *File Room* project, an ongoing electronic information file that exists on the World Wide Web to document instances of censorship around the world. *TVE: Primer Intento* was the first case to be entered.

Not surprisingly, many themes and formal devices found throughout Muntadas' video work reappear in his installation project commissioned by the Atlanta College of Art, which will take place during the 1996 Summer Olympics. In it he highlights the crucial if largely invisible role played by translators and translation at such an international event. As in video works like *Credits*, he seeks to bring to light the normally hidden apparatus that underpins mass visual spectacle—an apparatus personified in this case by the translator, who makes possible communication between the world's different linguistic cultures. Muntadas makes clear that the social terrain in which the translator's work takes place is already demarcated by the power relations that exist between the "dominant" and "marginal" languages of global culture. Employing video interviews with translators who work in both the political and cultural fields, he recalls the use of similar interview techniques in *Between the Lines* and *Between the Frames*, which also demonstrate the way that individual subjectivity accom-

Muntadas. **TVE: Primer Intento,** 1989. Stills from videotape.

modates itself to a preexisting social framework. In these respects, Muntadas' video works provide a valuable point of access through to his 1996 installation at the Atlanta College of Art, clarifying the place it occupies within a long-term, complex and fascinating artistic project.

NOTES

1. Muntadas, as quoted in Anne Bray and Ferol Braymann, "Muntadas: Personal/Public Conversation," *Video Guide* (Vancouver), June 1979; cited by Eugeni Bonet in "Second Attempt," *Muntadas: Trabajos Receintes* (Valencia: IVAM, 1992): 122.

2. Muntadas, from an interview in *Sites: A Literary Magazine on Buildings, Places and Monuments* 7 (1982): 3.

3. The catalog *Muntadas: Films, Videotapes, Videocassettes* (Madrid: Galeriá Vandrés, and New York: Video Distribution Inc., 1974) lists 16 film works and 21 video works for the years 1971 to 1974.

4. Muntadas as quoted in Berta Sichel, "Antonio Muntadas: The Images from the Media Landscape," *Artery* (November 1982): 2.

5. Dore Ashton, "Stadium V," *Contemporanea* 24 (January 1991): 24.

Stills from videotape were selected by the author and captured digitally.

El original es infiel a la traducción.

The original is unfaithful to the translation.

—Jorge Luis Borges

Found in Translation

RONALD CHRIST

We translate because we must—

because of the biological, neurological, cultural, geographical necessity to mediate our isolation. From Cicero to Kenneth Burke, at the least, thinkers have recognized in varying ways the human individual's isolation within its biological (mental + physical) system. William James states the case powerfully:

> Each of these minds [the particular I's and you's] keeps its own thoughts to itself. There is no giving or bartering between them. No thought even comes into direct sight of a thought in another personal consciousness than its own. Absolute insulation, irreducible pluralism, is the law. . . . Neither contemporaneity, nor proximity in space, nor similarity of quality and content are able to fuse thoughts together which are sundered by this barrier of belonging to different personal minds. The breaches between such thoughts are the most absolute breaches in nature.[1]

In other words, and despite Ronald Lang's attracting formulation in *The Politics of Experience*, my experience is *not* your experience; and the most we can attain is a signalling across the divide whereby I may bear my *expression* of my experience to your border, where my expression of my experience may even come to stand for your expression of your experience, or yours for mine or a combination of the two. If we do achieve such conditions or states, a nearly literal middle-ground between our absolute insulations, then we will have entered upon a transaction that we may term translation. (When Paul Goodman writes "I light fires I light fires/I light fires. No one comes." he epitomizes our insulation; he also translates his aloneness into a signalling physical

event that we may translate into our experience of aloneness, thereby entering upon a compact of cooperation in communication.[2]) It's easy to see why George Steiner writes: *"inside or between languages human communication equals translation."* [3]

Translation always occupies the "between," the wished-for common ground. Translation is an operation—subjective—of subjects aimed at other subjects, who from their subjectivity will occasionally formulate apparently objective norms, such as abiding by laws of grammar, general intelligibility. Translation, however, ultimately stands upon the will to bear *across*: translation is a transaction aimed at cooperation in belief, that is to say, existence. "Aimed at" because the transaction cannot be completed perfectly: after all, that pluralism is irreducible.

As such, translation is also the foundation of society and hence of politics, culture and all the rest of it. (Angels, the City of God are not translators; angels communicate directly into the minds of other immortals. Perhaps that's why Joyce, from a human point of view, dubbed them "messonger angels," relying on the reader to instantaneously translate the French in his Irish English in that book of books, more than any other a text as its translation.[4]) The ancients called this foundation *rhetoric*, the art of persuasion whereby cooperation was achieved and maintained, when it was; and they made translation basic to the pedagogy of rhetoric: a rigorous multilingualism, nimble negotiations in and out of others' idioms, aimed at developing the insulated speaker's ability to persuade—that is, to translate his audience's belief into his own. The ancients saw translation as a means within and to rhetoric; they did not see translation as a mode of persuasion or as persuasion itself. To this day people don't, and to this day we have no touchstone rhetoric of translation. There is no Art of Translation because translation is not seen as an art: it's a skill, a craft, an aptitude or even a knack. (Many would say, have said, the same about rhetoric.) Translation suffers from its lack of an Aristotle. (His existence and production, however, did not settle rhetoric's case.)

Correlatively, the ancients would not have understood our squeamish skirmishes about so called bilingualism. Chiefly, as inflicted in the United States, bilingualism has meant the avoidance of translation, of the negotiation *between* two (or more) languages, in favor of developing the individual's educational formation within a language viewed as "secondary" or "foreign" by a dominant language group. Teaching English, say, by means of translation exchanges with non-English speaking students (or with "secondary" speakers) has not been viewed widely as a means to the enrichment of the "native" speaker's language. While the ancient Greeks indeed labelled barbaric those who did not speak Greek (*barbaros* = foreign, from *bar-bar*, the sounds Greeks reputedly heard when foreigners spoke), the Romans had their students cast Latin into Greek, just as they had them cast prose into verse, and back again, as a movement toward greater flexibility and expressiveness in their own language. Neither Greek nor Roman doubted what was his culture's language or that language's worth; both understood how interlinguistic as well as intralinguistic negotiations (in the case of verse and prose, for example) profited. Why Johnny can't *hablar* may be a culturally more profound question than why he can't read.

* * *

So considered, translation, while having many specialized forms, should be viewed as a universal human activity. (The question is asked over and over: do the other animals have language? Yet the defining question, the actual basis of much of the work done with button-pushing chimps and bell-ringing dolphins is: can they translate?) One way to define this activity, necessary and inescapable, is to say that by means of translation we convey the world into our immediacy and actuality. That which is translated *means* to us, and even that which we recognize as "untranslated" undergoes the preliminary phase of translation into immediacy by being recognized as "untranslated." Another way to think about this activity is to propose: God is the ultimate

untranslated; His immanence a translating. The untranslated is literally the Original. That which was before we came upon it.

<div align="center">* * *</div>

Within the discrete system we each term self/body there are multiple systems of perception and identification, and therefore multiple records of perception and identification, that permit, require translation. There is the multitude within the absolute insulation, so that William James asked declaratively: "What Self We Love in 'Self-love'." [5] More radically, we say "I got so mad I saw red." We translate among our modalities, as the French Symbolist poets with their perfume symphonies and color vowels emphasized and as Hart Crane here translates to an American idiom and scene in his poem "Royal Palm":

> Green rustlings, more-than-regal charities
> Drift coolly from that tower of whispered light. [6]

Before it is a recourse and recreation of poets, *synesthesia*, the translation of one sense's information into that of another—"green rustlings"—is a condition of our everyday existence. Many modern musicians wear loud ties, architects unstructured clothing.

Other animals similarly translate within their own systems: an owl speeding down on its prey fixes in its sight that target—in translator's jargon one speaks of the *target-language*, the language into which the message is borne—but as the target approaches, the owl is anatomically unable to maintain its eyes on the prey and simultaneously to fix its claws in the same path: at a crucial moment the owl switches from the fixity of its gaze to the fixed line of its claws, with eyes literally averted: claws for eyes, a translative synesthesia.

<div align="center">* * *</div>

But *translation* is not a fancy or recondite term itself; we use it freely all the time. Look at this passage from *Coyote's Pantry*, an anthology of typical New Mexican seasonings and flavorings:

> People in the Southwest have always shared a common sense of destiny and adventure. In terms of the cuisine, this translates into a bold and creative style of cooking, and a willingness to borrow from the culinary traditions of all the peoples who have ever settled there or in regions nearby.[7]

The passage tells us much, even when we set aside its spurious cultural assumptions. For example, we may note that the context of this translation is commonality. Such a "common sense" is the foundation for translation: the base on which it arises, the structure in which it thrives. The gesture of translation is out from the commonly experienced—one's society, one's psyche—to the uncommonly or unusually experienced, most often viewed as the "foreign" or "alien." Without such a base in commonality the translated element or unit is apt to be viewed as invasive, coercive, perhaps lifeless. Second, there is an element of risk and excitement, a susceptibility to what a biologist might call *irritability*, a therapist *growth*. Hence there is a component of courage. Translation is courage—with a scope from foolhardiness or bravado to bravery—on the parts of translator and translated-to. A conclusion: openness to translation will measure an individ-

ENGLAND EXPECTS THAT EVERY

MAN WILL DO HIS

D U T Y

ENGAGE THE ENEMY MORE CLOSELY

ual's, a culture's courage. (Remember: courage is justice to the self. Paul Goodman says that somewhere in *Five Years: Thoughts for a Useless Time.*)

The passage waffles, typically: "In terms of the cuisine," it says, and those terms would include ingredients (blue corn, hot chiles), utensils (fajitas griddles, metates), methods (adovada, limed), etc.; but the writers link "terms" to "style of cooking," a phrase as useful here as a slotted spoon in eating soup. But this too is typical, helpful: when we get right down to it, we are lacking in precise, commonsensical terminology for discussing translation, rather than its resulting products. Academic textbooks exist, Steiner's grand map, but nothing much by way of what belongs familiarly to the layman. We lack an awareness of and an alertness to translation, its process and product. But let us recall Charcot's remembered rebuff to Freud: *La théorie, c'est bon, mais ça n'empêche pas d'exister.*[8]

Then the passage opens up splendidly: "a willingness to borrow." That willingness, which is a willingness to assimilate—perhaps a willingness to appropriate, in the lingo of the art world—is the informing spirit of translation: that willingness, that borrowing, and the willingness to acknowledge. The borrowing is of course a mode of the courage, and the borrowing, which comes in many modes, is a form of the *barter* William James mentioned; but, whereas James correctly saw the impossibility of psychic interchange, other forms of barter take place—my glove for your skates, this island for those trinkets, the government's printed paper for the company's automobile—and such barters are translations. Translation *is* barter: *this* for *that*, something of one order for something of another, with side-losses and gains according to the participants' interests and values, and with no gold standard. Too often verbal translations are judged from the basis of simile, similitude: this is like (or, very often, not like) that. Verbal translations are best judged from the basis of metaphor:

this *is* that—Cinderella's squirrel-skin slipper in French *is* an English glass slipper.

"All the peoples who have ever settled there or in regions nearby" takes us to the communalizing, across time and over space, that translation incites, promotes and accomplishes. Translation communalizes jumblingly and even jarringly, like every other active, vital communalization, but its stitching back and forth and over and under and through both time and space distinguishes it. It can pinpoint the other globally, it can spatialize the other universally.

So, then: is international or inter-regional cuisine translation? Do tomatoes and even chili peppers in the ketchup translate that original fish sauce into a specific, local accent any differently, *mutatis mutandis*, than *ketchup* did the Chinese *ke-tsiap*?

* * *

One thing, within a system, for another thing, within its system—both considered systemically—in cuisine or dreams may be considered translation, meeting the requirements of *movement* (actual or metaphorical) *across a boundary* (real and/or perceived) that involves an *exchange* of the moved on one side of the boundary for another on the other side of the boundary that fills a comparable place and use in its *bounded system*: osmosis is not translation. When Freud, a multilingual speaker and writer of great stylistic accomplishment, arrives momentously at an analysis of the mechanics of dreaming, which he terms the "dream-work," he fulfills the latency of his title: *Die Traumdeutung*: *The Interpretation of Dreams*:

> The dream-thoughts and the dream-content are presented to us like two versions of the same subject-matter in two different languages [zwei verschiedenen Sprachen]. Or, more properly, the dream-content seems like a transcript of the dream-thoughts into another mode of expression, whose characters and syntactic laws it is our business to discover by comparing the original

with the translation [Original und Übersetzung]. The dream-thoughts are immediately comprehensible, as soon as we have learnt them. The dream-content, on the other hand, is expressed as it were in a pictographic script, the characters of which have to be transposed individually into the language of the dream-thoughts.[9]

Emphasizing *interpretation* as the co-efficient of that movement across boundaries that characterizes translation, Freud categorized the interpretation of dreams, which he considered the royal road to the unconscious, as translation proper; and he saw, furthermore, that such translation was not solely between two languages (though many of his epigones practice that view) but, rather, that the translation of dreams stands in mirror relation to language as the Rosetta stone stands in relation to hieroglyphics. In other words, Freud saw the translation of dreams as a branch of semiology:

If we attempted to read these characters according to their pictorial value instead of according to their symbolic relation, we should clearly be led into error. . . . But obviously we can only form a proper judgement of the [dream-]rebus . . . if, instead, we try to replace each separate element by a syllable or word that can be represented by that element in some way or other. . . . A dream is a picture-puzzle [like a rebus] and our predecessors in the field of dream-interpretation have made the mistake of treating the rebus as a pictorial composition: and as such it has seemed to them non-sensical and worthless.[10]

Freud is at pains to guard against the allegorical interpretation of dreams: each element of the dream-rebus does not fit into a coherent system that matches, in one-to-one correspondence, a single element in a linguistic, narrative system; his interpretation is genuinely that then and no mere deciphering or decoding—activities that resemble translation in certain procedures or steps but with a lessened qualitative complexity. Interpreting *The Pilgrim's Progress* is qualitatively different from interpreting our simplest dream; contrastively, deciphering the message written on the body, as practiced within Jeannette Winterson's novel by that name, is qualitatively similar, by virtue of its tentativeness, provisionality. At any rate, *interpretation* is the essential. Early on, Lawrence Venuti defines typically:

> Translation is a process by which the chain of signifiers that constitutes the source-language text is replaced by a chain of signifiers in the target-language which the translator provides <u>on</u> <u>the</u> <u>strength</u> <u>of</u> <u>an</u> <u>interpretation.</u> [11]

Is it any wonder that Dante in the *Convivio* is so instrumentally antagonistic to translation?

Substitution of image for word is an act toward translation, one we all know from road-side traffic signs, though this instance generally and intentionally should lack the unconscious element of puzzle that drew Freud's notice. In fact, we have seen a gesture toward semiological Esperanto in these signs with their normalization under a design of inter-lingual intelligibility. A failed gesture, in my case, when it comes to the sign

that stalled me in incomprehension on a Spanish road:

But Esperanto, in any form, expresses the dream of translatability: *esperar* being Spanish, ultimately Latin *sperare*, for to hope.

The dilution and reapplication of Freud's insight by non-Freudian therapists may be glimpsed if we consider Rogerian analysis, in which the therapist guides the patient toward self-understanding by translating the patient to the patient. Rogers called his translative method "empathetic understanding," in which, he said, "I try to delve through complications and get the communication back onto the track of the *meaning* that it has to the *person*."[12] In the following example Rogers first quotes the narrative of a mother frustrated by her son

Jim and then records his own therapeutic translation:

59

> "The other day my sister-in-law came over for a meal and Jim was whistling during dinner. I told him not to, but he kept right
> on. Finally he did quit. Later my sister-in-law said she would have knocked him right off the chair if he had done that when
> she told him to quit. But I've found it just doesn't do any good to get after him that way." I said, "You feel that it wouldn't do
> any good to use as strong measures as she said." [13]

Such a transaction might be analyzed from the standpoint of inter-individual translation mimicking intra-individual translation; it propounds an illusion, useful for many, that one has penetrated the absolute insulation without sacrificing the insulated individuality. Furthermore, this sample epitomizes certain characteristics, ideals even, of translation, namely: *empathetic replacement* of the primary code by a secondary (an invisible emotion or a vestige of emotion colors the transaction or is imputed to it); *objectivity* achieved through subjective restatement; *benevolent censorship* in the interests of approved values (concision, perspicuity, etc.).

* * *

The language of dreams. How easily the phrase slips across page and tongue, with scarcely a hint or trace of metaphor or scruple. In part because we have come to accept as a sort of rare commonplace that everything is language—we read paintings, for instance—that even our lives are syntactic: one lengthening, periodic sentence, if we are inclined to the Ciceronian; a paratactic stutter of repetition, if to devalued Hemingway. This thinking typifies post-Sausserian linguistics and the theories arising from it; it informs a book and thinker such as *Written on a Body* by Severo Sarduy, and without it Sarduy's thinking about simulation, transvestism and animal camouflage as linguistic display is incomprehensible. [14] Translation itself is simulation, both as Sarduy conceives of it and as the idea generally circulates; transvestism, vulgarly viewed as paraphrase, is

translation ranging widely and wildly from the "fluent" or domesticating to the "foreignizing" or alien-affirming—from Rue Paul appearing in an advertisement "as" a female to the unshaven male participants in a Gay Pride March wearing wig, make-up and gown—in a reapplication of Lawrence Venuti's current terms[15]; while trans-sexualism translates so definitively as to detonate that sham criterion: fidelity to the author's text and intention.

If there is writing on a body, then there may be translation too. If everything is text, then everything is translated or at least translatable. (*Pace*, Dante, Frost, et al.) If everything is translated then everything is simulated. (But we already knew that: Baudrillard taught us so.) If we think that everything is text, then no wonder that we begin to speak of everything with the term *translation*. If in no other way, we live in an age of translation because we conceive it so. If life is text, translatable, it has always been so, and what distinguishes our time, in this respect, is our awareness, our increasing and extreme self-consciousness of it being so. Translators are apt to tell you that this is not an age of translation, certainly not a great age of translation; but translators talking translation will be talking shop and jealous of the term's honor and value. When computer people talk about "translating" among their "languages," on the other hand, they may be helpfully expanding the term's applicability and pointing in a direction we should sight down if not follow. Let us heed the implications of their jargon: *to port*.

* * *

Translation is parasitic: for *subject-language* read *host-language*; perhaps, though, we should read *para-site*, in the postmodernist manner. (Translators are indeed thought of as old-fashioned parasites: an art critic, known for her annual production, remarked about my translating: "It's good work, I suppose, if you can't do your own.") Translation is also *prosthetic*, not in the sense of something that deceptively *and* usefully substi-

tutes for what ought to be there, though that's the purpose of trots, ponies and cribs (and of our attitude toward those horsey thefts, which, like plagiarism, bring translation to the brink of, and sometimes over, the illegal), but in the fine sense that Marshall McLuhan initiated: an extension of our capabilities, our sense-abilities. The question might be neatly settled if we could decide whether translation belongs to the category of the fine or the useful arts; but, existing in the *of*, the *about* and the *in* of "between," translation may not submit to such a Solomonic solution.

<p style="text-align:center">* * *</p>

The Americas were discovered by mistranslation. Or, to translate: the Americas discovered themselves to people who mistranslated, from West to East, from Latinate to Amerindian, believing they knew where they were when they did not, willfully (mis)understanding speech when they had no means or basis for understanding it. (Later in our history, the Spanish conquerors would read to uncomprehending peoples a declaration claiming territory and all its resources for the foreign monarchy without so much as a gesture toward translation.) Like every act of translation, the discoverers' was an act of aggression: that it meant conquest when it pretended to comprehension, that it was wrong, incorrect, only characterizes its special condition, since all translation, whatever its motive or result, proceeds by taking a step toward the other: *ad + gradus*. Translation is, then, at once social and, less often recognized, political: translation aims at power, power over, by, through, for the other. In existential terms, translation speaks the Thou—from the Thou, for the Thou.

As a social act, translation requires two bases, most familiarly known, in the model of literary translation, as *source* and *target*, the language from which the translation is made and the language into which the translation is made. The act may be either interpersonal or intrapersonal or a combination of both. Columbus

engaged in interpersonal translation with the "Indians." An individual recounting his own dreams, even to himself, will be engaged in intrapersonal translation (dream imagery being the source, waking narrative being the target); and when audited by an analyst, the two will be engaged in indirect interpersonal translation of those same dreams as part of the psychoanalytic transaction. (The analysand must intrapersonally translate from the dreamed content to the narrated report, which translation will be an interpretation, at one remove, even before the analyst composes his interpretation at one still further remove.) Translation is never innocent, never neutral; the translator stands at the border or threshold of the two entities, one always pre-existing, the other coming into being by intervention of interpretation and never existing as more than provisional so long as it is recognized as translation.

But. Some translations, the King James Bible for example, may seem to achieve a fixed state of being "original"—giving rise, in that particular case, to the regrettably unapocryphal comment that if English was good enough for Jesus it is good enough for the present speaker—some translation, that is, might supplant an original, but in that case it loses its essential nature as translation and, of dialectical necessity, eventually requires translation.

This principle of third-hand originality, through cultural filtration, may be seen in James Fitzmaurice-Kelly's formulation: "When Albertus Magnus, St. Thomas Aquinas, or any other early light of the schools refers to Aristotle, it must be borne in mind that he often had no more exact acquaintance with the text which he expounds or confutes than could be gathered from an indirect Latin version of an Arabic rendering of a Syriac translation of a Greek original."[16] Such indirection might well lead to a consideration of a venerable sub-genre: the translation fraud, as in the remarkable cases of a translation into Latin from Greek, the *Liber gestorum*

Barlaam et Josaphat, a medieval monk's recasting of a life of Buddha that ultimately earned for the fictitious Barlaam and Josaphat a place in the Church's *Martyrologium romanum*, and of James Macpherson's suppression of his own verses in favor of those by an authentic 3rd-century bard, which he trumped up and passed off in 1761, in his own translation, as *Fingal, an Ancient Epic Poem in Six Books, together with Several Other Poems composed by Ossian, the Son of Fingal, translated from the Gaelic Language*. Like the monk before him, Macpherson, who never produced his "originals"—too costly to publish them, he said—had a genuine though different effect in the world and its literature; he is still accounted one of the greatest of Scottish writers, one who achieved immediate and influential translation into European languages, notably German and Italian. Macpherson's fake, then, was a genuine original, and must be distinguished from that master and masterpiece of all, the fake-fake translation of Cide Hamete Benengeli, *Don Quixote*, of which Cervantes claimed only to be the stepfather.

By such by-blows and bastardy translation may gain ascendent legitimacy; in its subservient, subordinate status, an apparent Golem, translation may become a delighting monster that creates its own doctor as well as its literally virtual reality. The career of Fernando Pessoa enacts this possibility several times over; Pirandello's *Six Characters in Search of an Author* proposes the question in agonies of regress; Orson Welles' *F is for Fake* exalts the primacy of the created fraudulent and its creator—ultimately himself, of course—nowhere more movingly than in translating a still of Picasso into a moving picture. It would seem that the suspicious air about translation incubates some of its accredited successes. Yet in all such transformations, whether fake or real imitation, if the target-translation does replace the subject-original, then some trace of the original, as Venuti might argue, ought to remain, so that we continue to recognize the translation as substitution. By their traces we shall know them.

* * *

These American continents are a site of, by and for translation; and Antoni Muntadas' installation in this hemisphere in the midst of a world-wide event that paradoxically canonizes a model of cooperation emerging from individuating competition—there can be no competition of the one, of the self-same—suitably recognizes translation, the movement across boundaries, as the ultimate and foundational media, the inter-*media*-ry by which peoples acknowledge their inherent separatedness in an attempt to overcome or circumvent it. Like all Muntadas' mature production, *On Translation* is medial; yet this work distinctively epitomizes his placement of subject and means directly in the between that is the province of translation, thereby renewing and newly defining a locus and meaning of his work. But not a new locus itself: recall his early piece showing an illuminated light bulb beneath an inverted and lighted candle, where the vacant synapse, the point of transmission, of translation focuses the objects; or recall *haute CULTURE*, where neither the ascending nor the descending tv monitor images the focus, the artist's focus, which is in the mechanism's fulcrum point; or recall *Media Sites/Media Monuments*, in which the juxtaposed images of identical places generate a medial between that is the artist's operation upon them. It is as if he works toward presenting, conserving the two sides, the subject and the target, simultaneously by concentrating on their mutual threshold: *The File Room* makes the absent present by recording and storing up the censored. Most precisely: **Between** the Frames.

Translation as practice, solution, evasion and triumph can never have been far from Muntadas' consciousness. Born into a Catalunya whose indigenous language was outlawed by a conquering Spanish in the figure of Franco, Muntadas grew up speaking a native Catalan and an imposed Castillian, translating between them as person and circumstance required. His target language often conflicted with his own subjectivity, which must have lain somewhere between.

* * *

But Columbus was a practical man. He did not concern himself with betweens, the exclusive territory for translators though not exclusive to them, because he was no wanderer himself but a go-between whose literal goal was to bring home the goods, one of the most valuable of which was the route to those goods. (In this respect his conduct illustrates a great truth about translation, though he was a faulty, inaccurate translator himself: the route to the source, followable by others, may exceed the value of what the source contains or is sought for, may indeed be the real commodity.) Columbus knew where he was going—a king and a queen and a fortune attested to that—and, like many a subsequent traveller with a planned itinerary, he saw and heard chiefly what he set out to see and hear. Faced with scatterings of an intruding continent, he viewed them only in the guise of the sub-continent he sought; confronted with people whom he could not understand, he translated their non-sense into his understanding. Notoriously, in a later episode of the hemisphere's translation, the name Yucatan was given to one of its sections in correspondence with the non-Indian Indian's reply to the Spaniards' question about what their homeland was called: "Ma c'cubah than," they said: "Don't understand you." ("Kangaroo" is said to have been the Aborigine's reply to a similar question about a native animal's name: "Kangaroo," he said: "I don't know.") Interrogating his journal for what he understood, learned, we uncover a wondrous state of incomprehension translated into meaning:

"They spoke many things among themselves which I could not understand, but I saw clearly that everything about us was a wonder to them. . . ."

"I have found among them neither idolatry nor any other religion. . . . None of our men could understand the words which they uttered."

"From what the Indians told me, [the island of Cuba] is of vast extent, great commerce, richly provided with gold and spices, visited by great ships and merchants. . . . <u>I do not know the language of the men here, they do not understand me, nor do I nor any of my men understand them</u>. . . ."[17]

What Columbus understands, what he translates into his own understanding, hops over the primary impediment to translation: knowledge of the source or original idiom. From his famous account we see that non-comprehension, non-understanding offer no impediment to the will to interpret. And again: interpretation characterizes translation: without it you may have the form, the activity itself, but not the impelling operation.

* * *

Q: With the video-taped interviews for Between the Frames *you accumulated a lot of material in the various languages of people variously connected with the art world. Did it occur to you to make these oral texts available to your viewers?*

Muntadas: *Well I thought about it. It was proposed at one point to transcribe and print these texts, and that was done. I liked that idea. But when they asked about translating the interviews from the original languages, I said no. No way. I didn't want the intervention coming from that angle, I didn't want the interpretation.*

If you allow that its operation in the movement across whatever threshold or border is what distinguishes translation as such, then you are poised to distinguish a horizontal spectrum of translation activities with varying ranges of intensity within that spectrum. For the purposes of criticism, literary translation, translation of *belles lettres*, has usually been taken to be the essence of translation, and hence the focus of study, as it is in Steiner's *After Babel*. Let us place literary translation, then, at the center of our hypothetical spectrum in

DRAWING ROOM OCCASIONAL TABLES.

range x, and let us place toward the left of this range all such translations as involve physical movement, the sort that are evoked by the word's etymology in *trans + ferre*, to bear across. These physical translations will occupy all the range, potentially infinite like any other portion of the spectrum, labelled x-. Let us place toward the right of x all those translations that are purely metaphorical, letting them occupy the range labelled x+.

Test the proposal's usefulness by placing the following items or their referents on the spectrum, or rather: on, along or off it, not necessarily limiting yourself to one location:

- Transubstantiation of the Host
- "It's not 'Old World elegance' (translation: the rooms are all brown) that I'm after."[18]
- "Sonnets from the Portuguese"
- "KHFM is brought to you by cable or translation."
- Constance Garnett's <u>Crime and Punishment</u>
- "TRANSTOK: VI.20 Stock Translator: TRANSTOK provides investors with an important capability for tracking stocks by acting as a 'bridge' between stock market quotes from databases, such as The Source, and software applications that let you analyze those stock prices, such as spreadsheets and database programs like 1-2-3 and R:Base."
- "AC2VIV is a collection of Autolisp routines and support files designed to translate Autocad R11 drawings into Vivid input files. The translator works within the drawing editor session and currently provides a nearly complete 'front-end' for Vivid. By making use of this translator, a user is able to construct a 3d-model, select a viewpoint, add lights and specify a Vivid studio structure, all within Autocad."
- "Bless thee, Bottom, bless thee! Thou are translated."[19]
- Transparent Language®

- Explaining to a friend your response to Muntadas' exhibit
- An astrological, palm or phrenological reading
- <u>Back to the Future</u>

Like Shakespeare we use "translate" to describe changes from one idiom to another, but also to name the change wrought in the translator—"wherefore do you so ill translate yourself out of the speech of peace that bears such grace into the harsh and boisterous tongue of war"—to name the act of explanation—"there's matter in these sighs; these profound heaves you must translate; 'tis fit we understand them"—and to name acts of conversion—"how many lambs might the stern wolf betray,/if like a lamb he could his looks translate."[20] We use it (euphemistically or literally?) to name the great exchange of death for life, heaven for earth; but we also use the term, increasingly, in ways and situations unknown to Shakespeare.

* * *

Traditionally, St. Jerome serves as image and patron of translators, owing to his founding translation of Christian Scripture into Latin; and the animals with him in Dürer's engraving of Jerome the seated translator, the lion and the fox, do suit translators with their double connotation of regal courage and foxiness. Here, as in most images of Jerome in this aspect, the saint is the Translator Contemplative; his work is still. (Jerome

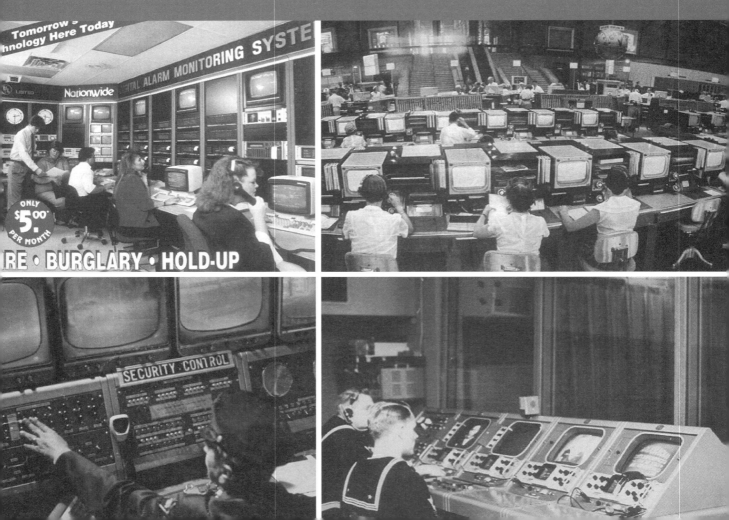

the penitent, the self-castigator is never imaged as Jerome the scholarly translator, so far as I know, yet many a translator would see the truth in such a merging.) More evocative, though, and all the more suitable, perhaps, for his desanctification in our time as well as for his being a patron not established by mere literalness of office (yet named far closer to the inherent meaning of translator) is St. Christopher, the trans-ferrer of the incarnate Word ("Formerly I was called Offero, the bearer; but now my name is Christopher, for I have borne Christ."[21]), in whose image we grasp translation as venturesome labor, humble service and sacred duty: the saint as image of the Translator Active, whose work is not only difficult but dangerous, requiring a staff's ground support, a guiding blessing from above, and an infirm hermit's illumination (Dürer again: 1521).

To begin with, Christopher's size inverts the usual relationship of translator/bearer to author/borne: Christopher was a colossus, all the more notable for putting his vast power at the service of another, but only the greatest and most powerful monarch. In the event, Christ weighs heaviest but Christopher looms largest: a parable for reviewers and critics of translation; the child embodies "the burden and the weight of all this unintelligible world,"[22] and the porter in general looks up to "the divine Infant, but sometimes also he is looking down and making his way painfully and anxiously through the rising waters; he seems bending under a miraculous burden. . . ."[23]—a parable of and for translators.

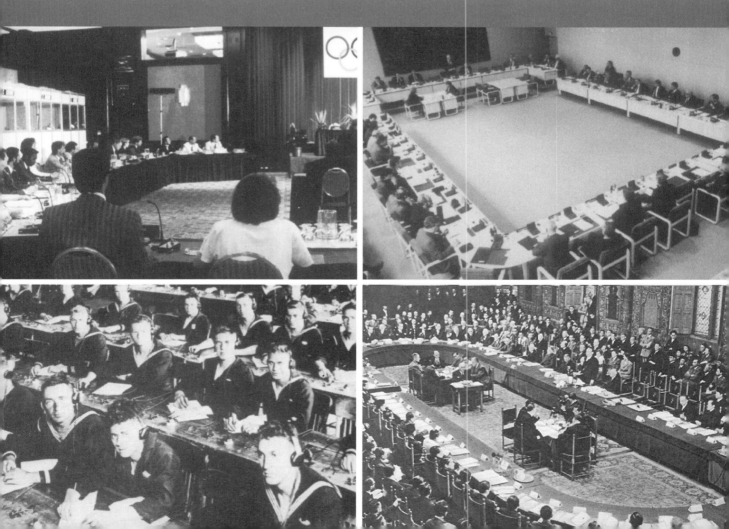

* * *

For example, mathematicians recognize the burden of transference in a Cartesian coordinate system, where two axes intersect at a point known as the origin: if this origin of the system is shifted to another point, without altering the direction of the axes, a mathematical *translation* is accomplished. Such translation, in the interest of simplification and clarification, is displacement without qualitative change (no altering of direction) but with quantitative change in the terms describing the point of origin. Such displacement occurs in the -x range and accords with the etymological, literal meaning of the word *translation*: to bear across, to move from one place to another.

In comparable cases, in cryptology, in software "translation," for example, there is a displacement in which the quantity being shifted is not affected qualitatively. We might better call such displacements *conversions*, in which each item of a given unit—a coded message, say—is converted on a *one-to-one basis* into a corresponding item of another unit—a deciphered message, say. In such conversions, there is a coordinate system, in which for each point a^1, b^1, c^1 ... x^1 on line 1, there is a corresponding point a^2, b^2, c^2 ... x^2 on line 2. Since there is no ambiguity or variability in the correspondence, once the systematic relationship is established, and since the systems remain essentially unaffected as systems, no interpretation is required, even though considerable interpretation may be required to determine the relationship among the units of either line 1 or 2. Once the code of the Rosetta stone has been cracked, each item in the code corresponds unambiguously to an item in the inscribed message, while the message may contain signs or referents that are in themselves ambiguous or mysterious.

Such conversions, transferals from one set of signs to another set of signs, whether they be verbal, pictorial, binary—and after all, the root of *translation* is closest to our *transferal*: *trans-ferre*—occur at the extreme left of our spectrum, even though they do not involve physical transportation literally. Near them we may place the experience described in Eva Hoffman's *Lost in Translation*,[24] where her being transported from Poland to the United States involved not only a translation through space but also an exchange of cultural terms as well as a "loss"—her being lost in the translation, her loss from the translation—owing to cultural differences in interpreting experience on either side of the boundary crossed. Hers is not a conversion, as described above, but something moving closer to central translation, owing precisely to the loss, to the possibility of such loss in the required and inevitable translations. In fact, we may say that the greater the possibility of such loss the greater our proximity to central translation; and in such a consideration, Robert Frost's aphorism that poetry is what is lost in translation says less about the essential nature of poetry than it does about the essential powers of translation.

When a Christian is translated from this life, however, there is a metaphorical use of the term since while there is a movement, a crossing, there is an intervening interpretation, and it is this intervention that qualifies the movement as translation. In fact this usage serves to take us back to the etymology, where the second half of the compounded word comes from *latus*, the past participle of *tollere* used as the past participle for *ferre*, so that we may say that if there is *transference* without toll, there is no genuine translation. In the mathematical example, which may stand for all literal translating, all *trans-lading* and *trans-ferring*, there is by rule no toll taken or exacted: only the position of the Cartesian coordinates is affected, not their direction. Despite the Latin, then, a translator is no mere transferrer: the translator raises up, weighs and exacts a toll,

and in that toll-taking is all his skill and accomplishment or lack. The toll taken, taken in the currency of the quantity transported, closest to a pound of flesh, is precisely what most critics and reviewers of translation do not wish to consider. They want to hear that the substance is as if not carried over, as if it originated on the side they found it: "a rendering so good that you tend to forget that the poems were ever written in Spanish," writes James Dickey in a blurb. [25] That's a compliment even more dubious than saying "he writes like an angel." The translator's duty is often spoken of, one way or another; too little recognized is translation duty itself. Translation has no free trade agreement. No possibility of one.

* * *

Lost in translation is the universal complaint, seldom offered as good-naturedly as in Eva Hoffman's book; but there are versos to that text, and they are not like the back side of a tapestry, which is what Don Quixote saw in translation: there is, for example, the comment of Borges, who grew up reading English, to the effect that the first time he read the *Quixote* in Spanish, it seemed like a bad translation, which matches Thurber's comeback to the lady who told him she preferred his story in French translation: "Yes," he replied, "it loses something in the original." The truth of such anecdotes aside, there is much to be said for what is *found* in translation, a subject George Steiner dubiously treats, I think, when he criticizes some translations for being better than their originals. Improving on the original is not what I have in mind, here, in speaking about the found in translation, and I will give an example from my own experience. For some time I have been translating a novel by the Chilean author Diamela Eltit, in which an ordinary city square provides the setting. In Spanish, this place is called *la plaza*, so I could have relied on the cognate *plaza* to render the novel's much-repeated noun in English, and this would have had the benefit of retaining, faintly, the noun's grammatically feminine nature; however, English also affords the word *square* for this place, which, while sacrificing, losing, the sex-

ual implication, introduces a strong structural element perfectly in keeping with the book's controlling geometrical imagery. On this one point, just this point, the structural system of imagery is stronger in the English than the Spanish will permit. Every translator knows similar instances, where his or her language system contributes a "found object" to the translation, not like the readymades of art, because they do not depend on displacement and re-viewing, but instead as though arising naturally, even automatically in the course of writing the target-language. Found-in-translation remains an underrated, relatively unexplored category in our age, not so in the Elizabethan.

The derided mechanisms of machine-translation, pitiable victims of condescending ignorance, may yet contribute greatly to this category, in addition to stocking us with still more risible mistakes: I overheard a woman at a neighboring table in a restaurant consulting her $19.95 miniature computer-translator for the meaning of the Spanish word *elegante*, only to be told that the word in English is *smart*. Not stupid. Not a mistake. (She did puzzle it out: the pedagogy of translation.)

While machine translation may take some getting used to—both to having it at our finger tips and to navigating it—and while the values in the example I cite below may perpetuate the stylistic cleansing of our language that has been in the ascendancy at least since the founding of the Royal Society in the 18th century—not that John Locke or Strunk and White, for that matter, would approve of the choices in the diction below—only the willful can ignore the example's potential for developing a common-person translator, even if not one to match the famous common reader. Here is "Tips for Better Translation," which I extracted from CompuServe's translation facility without leaving my Macintosh screen:

Although machine translation can usually produce an understandable draft translation, some messages may be confusing or unintelligible. You can help the machine translation system to produce its best possible translation by following these tips:

- Write short, simple sentences.
- Write complete sentences with correct punctuation.
- Check your spelling—if a word is misspelled, the software won't recognize it.
- Stay on the topic. The machine translation software is developed for translating messages about computers, and especially CIM [CompuServe Information Manager] software. Messages about other topics may not translate well.
- Use technical terms whenever possible. Technical terms usually have a single meaning, so they are easier for the machine translation software to translate. For example the verb "activate" translates better than "turn on" and "obtain" translates better than "get."
- You can use double quotes to prevent a word or phrase from being translated.
- Follow up on bad translations. If you get a translated message that is not understandable, post a reply asking the writer to rewrite their message. Often, simple corrections to the grammar and spelling can greatly improve the translation.

Although, for brevity's sake, I have omitted the illustrations this MTTIPS.TXT provides,[26] you can see how machine translation, in this very self-limiting example, works toward avoiding the notorious howlers. McLuhan correctly predicted everyone's becoming self-publishers; we may, in safe corollary, see how everyone may become inter-linguistic translators. The English-only game may not be the only game in the world after all. If Johnny can't *parler*, his on-line service can, becoming his linguistic-technological prosthesis (in McLuhan's sense).

Even if computers and their software never come to figure prominently in the direct translation of literature, they are already changing translation methods, just as they are changing methods (and results) in all literary study. Take for example, the case of Dene Grigar and Mindi Corwin, who used two programs, Storyspace and Perseus,[27] to comb the formulaic, repeating elements in the *Odyssey* and focus on the term *kerdea*, usually translated as "cunning intelligence." By establishing that Homer uses this term relative to Penelope as well as to Odysseus, that Antinoos even complains of her with the phrase *peri kerdea* (cunning beyond others, exceedingly cunning), Grigar and Corwin were able to verify how previous translators had failed to give Penelope her heroic due, even cutting her down, for example, as "clever piece," "supreme deceiver," "artful mistress," or neutralizing her brain's power: "greatly resourceful." The gender bias in such renderings glares, and their falseness distorts the narrative: "By setting up both Odysseus and Penelope as paragons of *kerdea*," Grigar and Corwin assert, "Homer creates tension and prepares us for the final confrontation between them, 'the trick of the bed'—truly one of the most exciting contests of wit found in the story." [28] In other words, this Herculean word crunching, all done swiftly by computer, resulted not merely in data but in valuable *interpretation* as well; furthermore, this interpretation rests squarely on a previous translation, the verbal into the visual, as the researchers were well aware:

76 Because we could create and follow any number of threads connecting these ideas, Storyspace became a multi-linear storage

and retrieval environment. . . . [T]he visual quality of these connections helped to structure and clarify our thinking by giving

us a visual representation of the thread we were tracking. (In fact, when we completed the linking process our Storyspace web

reminded us of the reweaving generally associated with Homer and Penelope in the <u>Odyssey</u>.) [29]

We must review the computer in its role as assistant—"computer-assisted translation"—and reconsider it as
a radical translator itself.

NOTES

1. William James, *Principles of Psychology* (New York: Dover, 1950), p. 226.

2. Paul Goodman, "Lines, and Little Prayer," in his *Collected Poems* (New York: Random, 1973), p. 92.

3. George Steiner, *After Babel* (New York: Oxford, 1977), p. 47. Steiner's thought and scholarship in relation to translation are so fundamental and extensive as to be nearly co-extensive with the topic. My not citing him at each point only indicates his total permeation of, not necessarily agreement with, what is said here.

4. James Joyce, *Finnegans Wake* (New York: Viking, 1939), p. 405.

5. James, *Principles of Psychology*, p. 317.

6. Hart Crane, "Royal Palm," in *Modern American and Modern British Poetry,* ed. Louis Untermeyer (New York: Harcourt, 1955), p. 317.

7. Mark Miller and Mark Kiffin, *Coyote's Pantry* (Berkeley, CA: Ten Speed, 1993), p. 93.

8. Sigmund Freud, "Charcot," *Standard Edition of the Complete Psychological Works of Sigmund Freud*, ed. James Strachey with Anna Freud (London: Hogarth and the Institute for Psycho-Analysis, 1953-1974) III, pp. 13, 13n.

9. Sigmund Freud, *The Interpretation of Dreams* (New York: Basic Books, 1955), p. 277. This edition corresponds to volumes IV and V of the *Standard Edition*.

10. Ibid., pp. 277-78.

11. Lawrence Venuti, *The Translator's Invisibility* (New York: Routledge, 1995), p. 17. I have added the emphasizing italics.

12. *The Carl Rogers Reader,* ed. Howard Kirschenbaum and Valerie Land Henderson (New York: Houghton Mifflin, 1989), p. 346.

13. Ibid., p. 69.

14. Severo Sarduy, *Written on a Body*, trans. Carol Maier (New York: Lumen, 1989). Sarduy's book and distinctive title, originally *Escrito sobre un cuerpo*, antedate Jeannette Winterson's similar title, *Written on the Body*, by several years and, while differing notably in content, register and timbre, nevertheless identifies along with her title and recurring image a veritable topos of modern thought and expression. Of course both trace a partial lineage from Kafka's "Penal Colony."

15. Venuti, *The Translator's Invisibility*, pp. 20, 60, passim.

16. *Encyclopedia Britannica*, vols. 27, 28 (1926), s.v. "translation."

17. I quote these passages, with my own emphasis, not from Columbus' own eloquent journals but from Tzvetan Todorov's *The Conquest of America* (trans. Richard Howard [New York: Harper, 1984], pp. 28-33) in order to signal the latter book's importance for the subject at hand as well as for the question of translation in general. Todorov subtitled his work "The Question of the Other," and that question precedes any other in translation. Or ought to.

18. Julie V. Lovine, "Real Estate Values," *New York Times* Magazine, 23 July 1995, p. 33.

19. Shakespeare, *Midsummer's Night Dream*, act 1, sc. 3, line 117.

20. Shakespeare, 2 *Henry IV*, act 4, sc. 1, lines 47-49; *Hamlet*, act 4, sc. 1, lines 1-2; Sonnet 96, lines 9-10.

21. Anna Jameson, *Sacred and Legendary Art*, vol. 2, in *The Writings on Art of Anna Jameson* (New York: Houghton Mifflin, 1895), p. 436. Most of the conventional details I present here derive from Jameson's spirited, skeptical account.

22. Ibid., p. 438.

23. Ibid., p. 437.

24. Eva Hoffman, *Lost in Translation* (New York: Dutton, 1989).

25. The blurb is for the third edition of John Frederick Nims' translation of *The Poems of St. John of the Cross* (Chicago: Chicago University Press, 1995). I am grateful to Carol Maier for supplying me with this example.

26. For instance, under the tip about technical terms, you find: "If the error detection feature is not turned on a message will be printed on the screen," which results in a French translation of *n'allume pas* for *not turned on*, which is emended to *n'est pas activée* once the English is revised to *is not activated.* Cogently written, punctuated sensibly, for the most part, the tips and examples offer a useful lesson in certain fundamentals; most important, they are self-limiting (computer talk).

27. Storyspace, as its name implies, permits the spatial organization and reorganization of material by means of maps and moveable, linked boxes; Perseus is an interactive repository of illustrations and texts as well as critical and scholarly sources related to Ancient Greece.

28. Dene Grigar and Mindi Corwin, "The Loom and the Weaver," *The Active Link* (Summer 1995): 3.

29. Ibid., p. 2.

Biography

Muntadas was born in Barcelona in 1942. He moved to the United States in 1971, and now lives and works in New York. His videotapes and installations often explore the transmissions of information through systems, and have been shown in numerous exhibitions worldwide. He has taught and lectured widely, including at MIT, Cambridge; the University of California at San Diego; the Universidade de Sao Paulo, Brazil; and the Ecole Nationale Superieure des Beaux-Arts, Paris.

Selected Videography

Acciones. 1971. 12 min.

Tactile Recognition of a Body. 1972. 18 min.

Transfer. 1975. 18 min.

Snowflake. 1977. 22 min.

Liege 12/19/77. 1977. 18 min.

On Subjectivity (About TV). 1978. 50 min.

Between the Lines. 1979. 25 min.

Watching the Press/Reading Television. 1980-81. 10 min.

Media Ecology Ads. 1982. 14 min.

Credits. 1984. 25 min.

Political Advertisements I (in collaboration with Marshall Reese). 1984. 35 min.

Media Hostages (S.S.S.). 1985. 5 min.

Slogans. 1986. 35 min.

Cross-Cultural Television (in collaboration with Hank Bull). 1987. 35 min.

Political Advertisement II (in collaboration with Marshall Reese). 1956/1992. 42 min.

Warnings. 1988. 7 min.

TVE: Primer Intento. 1989. 40 min.

Video Is Television? 1989. 4 min.

Political Advertisement III (in collaboration with Marshall Reese). 1956/1992. 54 min.

Portrait. 1994. 6 min.

Marseille: Mythes et Stereotypes. 1995. 53 min.

La siesta/the nap/dutje. 1995. 6 min.

S.M.E.P. 1996. 35 min.

Selected Installations

Confrontations. 1974.

N/S/E/W. 1976.

The Last Ten Minutes. 1976-77.

La Television. 1980.

Media Eyes (in collaboration with Anne Bray). 1981.

Media Sites/Media Momuments. 1982.

haute CULTURE. 1983-85.

Exposicion. 1985.

This Is Not an Advertisment. 1985.

Exhibition. 1985.

The Board Room. 1987.

Quarto do Fundo (The Backroom). 1987.

STANDARD/Specific. 1987/89.

Stadium I-IX. 1989-93.

Home, Where Is Home? 1990.

The Limousine Project. 1991.

Words: The Press Conference Room. 1991-93.

City Museum. 1991-95.

Free Trade? 1993.

The File Room. 1994.

Ici/Maintenant. 1994.

Between the Frames: The Forum. 1994.

On Translation: The Pavilion. 1995.

Des/Aparicions. 1996.

On Translation: The Games. 1996.

Recent Catalogs

Muntadas: Intervenções: A Propósito do Publico e do Privado (Porto, Portugal: Fundãçao de Serralves, 1992). Texts by Michael Tarantino, Nena Dimitrejevic and Alexandre Melo.

Muntadas: Trabajos Recientes (Valencia, Spain: I.V.A.M., 1992). Texts by Margaret Morse, Eugeni Bonet and Heidi Grundmann.

Between the Frames: The Forum (Bordeaux, France: capc Musee d'art contemporain, 1994). Texts by Catherine Francblin, Mary Anne Staniszewski, et al.

Between the Frames: The Forum (Columbus, Ohio and Cambridge, Mass.: Wexner Center for the Arts and List Visual Arts Center, MIT, 1994). Texts by Debra Briker Balken, Bill Horrigan, et al.

Muntadas: Des/Aparicions (Barcelona, Spain: Centre d'Art Santa Monica, Generalitat de Catalunya, 1996). Texts by Eugeni Bonet, Robert Atkins and Josep Maria Montaner.

Selected Bibliography

Atkins, Robert. "Muntadas in the Lair of the Media Monster," *Center Quarterly* 42 (1990): 8-10.

Simons, David. "Muntadas Out of Context," *Ear Magazine* (May 1990).

Ashton, Dore. "Muntadas: Stadium V," *Contemporanea* 24 (January 1991): 24.

Mahoney, Robert. "Muntadas: The Limousine Project," *Flash Art* 157 (1991): 157.

Mantegna, Gianfranco. "Interview: Muntadas," *Journal of Contemporary Art* (5, no.1, Spring 1992): 77-87.

Melo, Alexandre. "Os poderes dos lugares," *Expresso*, 16 May 1992.

Amar, Sylvie. "Antoni Muntadas, le temps du dialogue," *Art Press* 177 (February 1993): 17-21.

Gale, Peggy. "Muntadas: Searching between the Frames," *Parachute* 70 (April-June 1993): 8-13, 51-57.

Mari, Bartomeu. "City Museum," *Sites* 25 (1993).

Conomos, John. "Antonio Muntadas," *Art and Text,* (January 1994): 76-77.

Gauville, Herve. "Muntadas, le monde congédié par l'écran," *Libération,* 24 May 1994, p.31.

Heartney, Eleanor. "Reframing the Eighties," *Art in America* (November 1994): 104-9.

Morgan, Robert C. "Muntadas," *Kuntsforum International* 125 (January-February 1994): 133-35.

Snodgrass, Susan. "Public Domain, Muntadas and the File Room," *New Art Examiner* (October 1994): 48-49.

Atkins, Robert. "Art on Line," *Art in America* (December 1995): 58-65.

Tarantino, Michael. "Muntadas, Galerie de l'ancienne poste," *Artforum* (February 1995): 99.

Photographers:

Daniel Azelie
Tiffany Bauer
Eugeni Bonet
Caterina Borelli
Stephan Hillerbrand
Studio Claer Hout
Frederic Delpech
Denis Farley
Dirk Gysels
Manfred Jade
Timothy P. Karr
Wolfram Lanzer
Ruby Levesque
Dirk Loech
Tino Martinez
Paul Maynes
Charles Meyer
Andre Morin
Muntadas
Pedro Ortuno
J. Pingarron
Rocco Ricci
Juan Garcia Rossell
Joan Sagrista
R. Samrud
Kok Storm
Jeff Ward
Antonio Zafra

Cover Photography & Design:
Andrew Blauvelt